BROWN DOG
OF THE YAAK

THE CREDO SERIES

A *credo* is a statement of belief, an assertion of deep conviction. The *Credo* series offers contemporary American writers whose work emphasizes the natural world and the human community the opportunity to discuss their essential goals, concerns, and practices. Each volume presents an individual writer's *credo*, his or her investigation of what it means to write about human experience and society in the context of the more-than-human world, as well as a biographical profile and complete bibliography of the author's published work. The *Credo* series offers some of our best writers an opportunity to speak to the fluid and subtle issues of rapidly changing technology, social structure, and environmental conditions.

Brown Dog of the Yaak

Essays on Art and Activism

ESSAYS ON ART AND ACTIVISM

Rick Bass

Scott Slovic, *Credo* Series Editor

Credo

MILKWEED EDITIONS

(800) 520-6455; www.milkweed.org
Distributed by Publishers Group West
Published 1999 by Milkweed Editions

Cover design by Rob Dewey
Cover photograph by Don Jones
Author photo by Graham Baker
The text of this book is set in Stone Serif.
14 15 16 17 18 5 4 3 2
First Edition

Epigraph on p. viii is from Beryl Markham, *West with the Night*
(San Francisco: North Point, 1983), 38.

Milkweed Editions is a nonprofit publisher. This book has been
partially underwritten by Joe and Harriet Foster. We gratefully ac-
knowledge support from our World As Home funders: Lila Wallace
Reader's Digest Fund; Creation and Presentation programs of the
National Endowment for the Arts; and Reader's Legacy underwriter,
Elly Sturgis. Other support has been provided by the Elmer L. and
Eleanor J. Andersen Foundation; James Ford Bell Foundation; Bush
Foundation; Dayton Hudson Foundation on behalf of Dayton's,
Mervyn's California, and Target Stores; Doherty, Rumble and Butler
Foundation; General Mills Foundation; Honeywell Foundation;
Jerome Foundation; McKnight Foundation; Minnesota State Arts
Board through an appropriation by the Minnesota State Legislature;
Creation and Presentation Programs of the National Endowment for
the Arts; Norwest Foundation on behalf of Norwest Bank Minnesota;
Lawrence and Elizabeth Ann O'Shaughnessy Charitable Income
Trust in honor of Lawrence M. O'Shaughnessy; Oswald Family
Foundation; Ritz Foundation on behalf of Mr. and Mrs. E. J. Phelps Jr.;
John and Beverly Rollwagen Fund of the Minneapolis Foundation;
St. Paul Companies, Inc.; Star Tribune Foundation; U.S. Bancorp
Piper Jaffray Foundation on behalf of U.S. Bancorp Piper Jaffray; and
generous individuals.

Library of Congress Cataloging-in-Publication Data

Bass, Rick, 1958–
 Brown dog of the Yaak : essays on art and activism / Rick Bass.
 p. cm. — (Credo)
 ISBN 1-57131-227-7 (cl). — ISBN 1-57131-224-2 (pbk.)
 ISBN 1-57131-236-6 (cl ltd ed).
 1. Bass, Rick, 1958– —Homes and haunts—Montana—Yaak
Valley. 2. Human-animal relationships—Montana—Yaak Valley.
3. Environmental protection—Montana—Yaak Valley. 4. Dog
owners—Montana—Yaak Valley—Biography. 5. Authors, Ameri-
can—20th century—Biography. 6. Hunting Dogs—Montana—
Yaak Valley. 7. Yaak Valley (Mont.)—Biography. 8. German short-
haired pointer. 9. Authorship. I. Title. II. Series: Credo
(Minneapolis, Minn.)
PS3552.A8213Z468 1999
333.78'2'092—dc21 98-50947
 CIP

This book is printed on acid-free, recycled paper.

To Colter, Tom and Nancy, Jarrett,
Tim and Maddie

Brown Dog of the Yaak

It was not like a herd of cattle or of sheep, because it was wild, and it carried with it the stamp of wilderness and the freedom of a land still more a possession of Nature than of men. To see ten thousand animals untamed and not branded with the symbols of human commerce is like scaling an unconquered mountain for the first time, or like finding a forest without roads or footpaths, or the blemish of an axe. You know then what you had always been told—that the world once lived and grew without adding machines and newsprint and brick-walled streets and the tyranny of clocks.

—Beryl Markham, *West with the Night*

Brown Dog of the Yaak

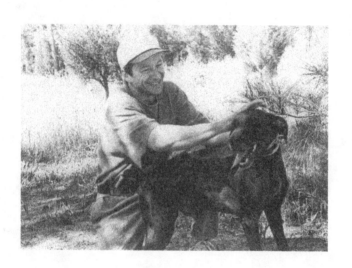

BROWN DOG
OF THE YAAK

ESSAYS ON ART AND ACTIVISM

by Rick Bass

I COLTER

My dog Colter had a bomb in his heart. Such was the incandescence within him that his eyes would glow fiery green when he was hunting. He had a big bony head, like Cerebrus, I suppose. He was a German shorthaired pointer, solid liver colored—brown as a deer turd in the shadows, but with vague tinges of red in the sunlight—and he had a huge chest and a little waist and a perpetual grin. Every muscle stood in sharp relief from his ceaseless charging up and down hills as he followed the intoxicating rivers of scent that course through these lush, green, ferny forests. He would rush like a dervish, left and right, when he hunted, leaping fallen logs—back and forth, as if crossing some burning river, his eyes glowing like candles all the while—and the birds would scuttle ahead of him in terror, as if all their ancient and abstract fears had leapt into birth, or metamorphosis,

3

from nothing more than the old knowledge lying latent in their blood.

His breath was as hot as a blowtorch. The ground drummed beneath his feet, such was his speed, and the force of his leaps, when he landed. He spent a large percentage of his time airborne. I would hurry along behind him, thinking: A man or a woman would have to be brain-dead, not to feel anything in this pursuit.

Flushing dogs, such as golden retrievers and springer spaniels, are bred to frighten the bird into flight—to cause it to leap into the air at close range to the hunter, so that the hunter may then fire.

Pointing breeds, however, like Colter—the Brown Bomber—have been bred to find the bird and approach it, and then to freeze staunch as a statue right over the hidden, huddled bird—revealing the secret of it, but stopping shy of flushing it, and to instead hold it as if frozen in time until the hunter approaches and kicks at the brush or clump of grass with his foot, and the bird then panics and leaps into flight.

The dog—pointing to an invisible bird, one you'd never know was there otherwise—has always seemed magical to me.

And I have also an affinity for the minds of pointers. I do not mean to imply that they are dumb—they are marvelous miracles, geniuses, each of them—but when I think of a pointer, so similar to a hound, I think of raw brute power coupled with an exquisite scenting nose, and the ability to learn one

thing—*birds*—very well. Beyond that—well, they're no Einsteins.

Sometimes I get a little nervous when considering the possibility of owning one of the flushing breeds, such as a golden, or even a lab: dogs who have multiple talents. I would never want to own a dog who was smarter than me. I want one that can run harder and scent better and perform magic. That's all.

A pointer's not the best dog to run in the north woods where I live, and especially not a big-ranging dog like Colter. But I have made the mistake of falling in love with the thing itself, the dog, rather then the issue of, say, putting grouse on the table every night. A spaniel or retriever would fit these woods, and this species—ruffed grouse—far better, far more elegantly and precisely. But Colter fits my heart.

The discrepancy between those two fits, the two places, sets out a distance of travel, the passage of which is exhilarating. I loved to turn the big brown dog loose into the small tight woods—you can't see farther than ten or twenty yards, and then only in glimpses—and to listen to the forest shake amidst his bedlam, to the music of grouse wings whirring.

Sometimes the grouse fly into the next county, though other times they'll be so startled that they'll simply leap up into the branches of the young lodgepole pines and perch there as if gone to roost for the night, murmuring nervously and sometimes leaning forward to peer down at the dog howling below.

That was another of the great things about Colter: whenever he would bump a bird up into a tree, he would remain on point but would howl and bay and sometimes scream like a panther to let me know the bird was up there, and for me to come and flush it again, and to try to shoot it when it flew, if I could, and if I wanted.

The best hunting was during the good years of grouse—they're notorious for their up-and-down cycles. In a low year, you'd find just one or sometimes two grouse hanging out together, but in a high year you can find them in coveys of eight or ten birds, so that when the dog, ahead of you, points one, and it flushes and you shoot, you can remind the dog *Whoa!*—usually with a yell, in your excitement, which is not all your excitement but some wonderful combination of the dog's and the bird's—a thing far larger than yourself and certainly larger than the sum of any parts—and then you can whisper *Okay,* and like an assassin your burning dog will creep forward, skittering and scooching, nose snorkeling the ground and the air in the blind-crazed scent-puffs, moaning with joy, knowing the birds are *right there,* and that he can no longer run big and wild or he'll scare them, but nonetheless having all this excess physical energy, physical power—and *bam!*—his nose will find another one, and he'll freeze midstep as solid as if cast suddenly in bronze, or in some substance more taut and dense than bronze.

He will not blink. His unseeing eyes might be looking directly at the huddled bird but he will not see it with his eyes but with the wavering, pulsing,

imprints of scent that are painting themselves like some rank oil with gobs of earth and feather and smears of blood and adrenaline across the ridged canvas of his brain, which was his mother's and father's brain before his, and their mother's and father's before theirs—and which I, lucky man, have been made curator of for this brief span of time—briefer than I can ever realize, as I hunt this brown genie, this magician, who will disappear at the age of four, his talent-in-the-world still rising.

He will leave me bereft of a hunter and friend, clumsy, numb. I will be robbed of that intoxication, that hyper-inflation of the senses, so that it will be as if I got to catch only a glimpse of his wonder, and the few times I shot well and shared in his magic—the bird warm and feathered in my hands, and his panting grin, a thing shared quickly between us in his green eyes—those few times I had with him, four years, seem now in memory almost like a dream: as if in that time I had ventured—traveling the edges of shadows, or along invisible wires—to some other land.

Though sometimes, too, it seems that memories can be as real as feather and stone; as real as if walking along some stone pathway littered with yellow leaves in the autumn—and that it is now the memories that labor to hold together those stones or boulders. As if—despite my knowing better—memories had been created so vividly as to become almost as physical—as durable, if not irreducible—as those stones or boulders.

What is the opposite of art, or artifice? How

much does the artist need that opposite thing in the world, with which to weave? Does the physical world of stone need memory-dust? Surely memories, and stories, require stones, boulders, trees.

Still other times—the perfect times—Colter would not bump the bird over the horizon, nor up into the trees, but would catch it flat-footed out in the open, unprotected; and on these occasions he would occasionally, despite his youth and fury, hang way back, in order to avoid spooking the grouse—this bold dog assuming the treacherous, deceitful mask of timidity, prudence, and forbearance—pointing the bird not nose-to-nose, but across that distance of ten, even twenty yards— and such (on those handful of occasions when I saw this happen) would be his pretension-of-lightness that often the grouse would not only hold tight where it was but would even be fanning its tail like a turkey, trying to claim or defend its territory against this hesitant interloper.

I don't know what got into Colter, on those occasions—why he played a patsy, when it was so much otherwise his nature to zoom in on the bird. Perhaps he was simply learning that's what it took, to creep in on those kinds of birds. Perhaps he was learning to be two things: a hard-charger on the prairie landscapes of pheasants and quail, but a creeper and timid slinker in the forests.

In any event, those few times I saw him holding a skitterish grouse on point, it seemed that he did it almost by hypnosis. I would arrive a little late on the

scene, and because I hunt in the late afternoons, the soft autumn light of the forest interior would be lying down almost level upon the dog and the fanning grouse, and their eyes would be gleaming like rubies. Colter would be on point, of course, frozen statuesque, but in a slightly different way, one that told me he was seeing the bird with his eyes, rather than with its odors being painted upon his palate.

It would seem to me—though I do not know how I could ever have measured or proven this—that for him the intensity of eyesight was slightly more subdued than that of the olfactory system. He would seem just a bit calmer, slightly more relaxed, and breathing a bit more steadily; and whether this was part of his act to hypnotize the bird, or a true thing from within, I'll never know.

The bird would have hopped up onto a log or stump and would be in the center of a small clearing, fanning its barred red or gray tail, the tail etched in light, so that it gave the illusion that the bird was on fire, or glowing: and it occurs to me now that, great as Colter was, perhaps the hypnosis was working both ways.

The artist, I suppose, would withdraw at this point; would try to whistle the dog away from his quarry—even if he or she had to lay the gun down and pick the dog up, as if hefting a concrete statue, and tote him off to some great distance sufficient for the dog to forget that image of, and desire for, the bird—which, in Colter's case, would have been the equivalent of carrying him to Jupiter, or beyond:

carrying him not for some distance measured in miles, but in years—carrying him half the distance of his life, or even further, on across into death—and even then I am not sure Colter would have been able to forget that bird, and the indignity of being taken off the scent. The hypocrisy and inconsistency of my having first asked one thing of him—to find the bird—only to then change my mind, once he delivered that to me, and to ask him to do the opposite, would not have been, to say the least, graceful with the natural world, to my way of thinking, nor to the world Colter and I inhabited in the fall. It never occurred to me *not* to step forward and flush the bird, and attempt, in that wing-whir of a second or two—fifty miles an hour of blur, at the end of the first second—to shoot it.

The dog's eruption of excitement, afterward, was as if in shooting and obtaining the bird I had rescued or even resurrected the dog from that place of trance.

Should such dogs have been born into the world? Or such humans who love and hunt with them?

I can't quite tell you what it was like for that brown dog—that staunch anchor, the strewn chest—to disappear from my life, leaving me hanging. But the distance of what it was like—being with him in the woods in the autumn, and now in the autumn staring out at the yellow aspen and cottonwoods and new north winds and being in the woods without him—the distance between those two places is like the distance had I picked him up when he was on point and carried him away from that bird.

I suppose the word for him—for what he had—was brilliance, which is a term I don't think we use well. There was a brilliance in his eyes, and in the eyes of the grouse, back in those late-day sunlit woods. There can be a brilliance of irreducibility, of a thing not being puffed up or constructed to some value beyond itself, but being whittled and worn down to its essence, like the one crystal of a gem. Artists have long known and strived to capture this.

There can be the brilliance of experience. We're used to the notion of a brilliance outside of things, also. Too often, perhaps, we turn the word to focus inward, rather than using its older meaning of providing luminosity—of a thing outside our grasp, shining. A writer or other artist need not be brilliant within, nor wise, to produce work that might possess these attributes. The reason is that the tools with which the artist works—the language, the invention of it, and the shape and power of the words themselves—can be brilliant, beyond the worker.

But a dog like Colter carries a brilliance in his blood.

The hunter who makes a difficult shot is not the brilliance in the equation; the woods are brilliant, for holding the grouse.

Soon it will be time to talk about the valley of the Yaak: this strange, dark, wet, inhospitable place. By no means should this swampland be confused with a place to visit for, say, a vacation. It has little to offer in that regard, and the handful of residents here would

frankly be unhappy to see you. (Nothing personal; they just would.) This first part of this book is a biological discussion of place—not a recreational one.

And then, following this discussion, it will be time to talk about the artistic aspects: to talk of the writing about this place, and the need to keep the last roadless areas there as they are—roadless. To talk about the shadows cast from this place, rather than the essential reality of it. But first I want to say a little more about the brown dog who was born and raised and hunted in this valley. His blood shaped him, surely—the wild field-trial blood of his big-running father, and the sweet blood of his friendly mother—but the minute he was born, the valley began carving and sculpting him. And in the very near end, it seems—unless he shows up by some great movement of magic—he did not quite fit the valley.

He sculpted, influenced a few grouse—the ones that flew away.

The hills, the mountains, sculpted his chest, his lungs. The breezes of scent awakened and stimulated that sparkle, which he carried in his blood. But he did not learn caution or forbearance—learned, or knew, only to burn brightly—and I cannot help but think that might have had something to do with his early disappearance.

But now I am comparing a thing of essence to a thing of shadow.

Some shadows, or lines of connection between the physical and the imagined, are long while others are short, but there is still, I think, always a distance

between the two, a distance that is good for artists to be aware of.

Shadows, or ideas, or emotions, carry immense power—call it magic—and possess the ability to then give birth to real things—as those ideas themselves were birthed from the stones, or other real things, so that it can be a continuous cycle, essence to shadow to essence—but it seems important not to confuse the two.

Writing about the need to protect those last cores of wildness in the islands of remaining roadless areas is not anywhere near the same as those roadless areas themselves. It seems like an easy enough realization, but it's one we keep forgetting. If you're going to write about stone, over the long run it's probably best if you handle a lot of stone. There can be a power (and from that, a magic) generated by your passage back and forth, from subject to shadow-of-subject.

Maybe that's all I'm trying to get at, here: that it is important to know when to get up from your desk, and when to sit down at it—and that you move back and forth between the two places, *living* versus *writing,* with some semblance of balance (lest you disappear)—and that you try always to remember that the subject is more important, or more powerful, than the shadow of the subject, which is your artistic treatment of the thing. And to try to find the line, the measure, of that distance.

I don't mean to diminish the importance of writers or artists, in relation to their subjects. I'm just a little weary of artists being called brilliant when really

art is a great mystery. We enter into stories like lost explorers wandering into rooms or palaces or even countries of vast wealth.

We plunder—sometimes with timidity, other times with cunning, or endurance, or speed, or power—but when we come back with shining objects, it is not we who were brilliant but the places to which we traveled. Maybe there was something in our blood that hinted those places might be out there. But anyone who has ever written or made something wonderful knows intimately how much luck and grace is involved; and when people—critics—start saying how fine a reader or writer is—well, I get annoyed when a reader or writer starts believing that and forgets how damn much mystery is involved.

More and more I think a style of writing is not a trait or characteristic you have—a voice, yes, but not a story—but rather, a place you go to.

It's why experienced writers can produce such shit. It's why beginning writers can lay out, or discover, or stumble into, such wonderful work.

Stories are passages for the writer at least as much as for the reader. We do not have control. At best we walk or stumble (or run gracefully) across brilliant lands, and possess a nose, or an affinity, or a desire for certain lands, and certain treasures.

Hunting with Colter: I needed him like an addict needs opium, or a drowning person needs a rope. Beyond my loving the essence of what he was, and what he did, hunting with Colter was a time when I

did *not* think about the environment, and did not think about writing, or craft. All day long I could just pin my ears back and move ahead while the dog did the manic casting, left and right, left and right, up the hills and down the coulees, and it comforted me to see that doing so gave him great joy, and afterward, peace, rather than torment. He did not struggle against the shape of the land in order to get to the focus of his desire.

In the evenings, back at the little hotel room, or at home on the porch, I would sit beneath the porch light with him in the cold night air and pluck the drifting feathers from the grouse or pheasant, would eviscerate the birds, and trim off the heads and feet, then rinse them and wrap them for the freezer. Colter would sit there next to me, gaunt from the hunt's labors and a bit shivery: this wildebeest of a dog reduced almost to a blade, but now—or so it seemed to me—completely irreducible beyond that point. And I would be very strongly aware, at day's end with all our deeds done—his hunting, my shooting—of the hugeness of the distance between that last act, plucking the bird with the dog sitting there next to me, versus what would be coming the next morning: writing. It would seem light-years away—sketching those hieroglyphs, symbols of all the senses etched upon flat sheets of paper—and I would marvel at how far I would have to travel from the porch with my dog and those birds, to get all the way to that place of pretend-and-make-believe by the next morning. The recognition of that distance would be

a good feeling, a calming one, for I would know somehow that that distance from art—for a while—was good for me, as a breath of air can be said to be "good" for a drowning person.

I can't tell you how balanced I felt by that goofy brown dog. While I was riding daily those up-down roller coasters of writing in the pretend world—up and down like the rhythm of some mindless sewing-machine needle—he was loping laterally, casting left, then swinging back right, so that I felt often, for long stretches of time, that our movements and our lazy lives together were like those of some brown atom, with our energies spinning not in opposite or parallel directions, but complementary, and generating a balance that was pleasing first to us, and from that, to the world.

His brown face, his long wolfy snout, would be latticed raw with rubbed spots from where he had been charging through the brush in the cold weather. He charged in a fashion that could almost be called, in the best sense of the word, *mindless:* ordered not by my entreaties, but by the sunlight in his blood, and the old dead dogs below him—the legacy, the genealogy. And in days to come that facial latticework would form tiny white scars, so that it looked like white whiskers. Sometimes his eyes would be swollen nearly to slits, but he would moan and then purr like a cat in the evening when I petted him, so complete had his day been; and at home when he slept back in the utility room with the pack of other, "regular" dogs, a tangle of heads atop others' haunches—a nest

of dogs, and a tangle, perhaps, of dog dreams—I never saw a dog sleep so loose and happy.

Looking in on that sleeping dog at night, after a good hunt, before going up to my own bed to turn in for the night, en route to the next morning's slow seated work, it would seem, always and again, that one of those two elements, *the dog,* was always real, and the other, *the writing,* always shadow. A beautiful shadow, but a shadow nonetheless. And the distinction always seemed supremely important; as if the sharper-edged the reality, then possibly the sharper-edged the dreams, the shadows.

I don't mean to dismiss the shadow-life as insignificant: far from it. But it seems a great danger to me for a writer to become lost in, or too much in love with, the shadows themselves, and his or her trafficking in them, rather than the objects themselves, which cast those shadows.

I mean to marvel at the strange, lonely distance created by that slight separation between object and shadow, no matter what their similarities. I think this distance, this longing, can be a good thing—a fuel that drives us to approach more closely, along the paths of shadow-lines, those anchor-places—stones, rivers, the world—through tricks-of-shadow, with dark ink moving across the blank white page.

When he disappeared—after he disappeared—I would write ten, fifteen pages a day—writing about him, about hunts we'd taken, and trying to capture the way he was—but in the end, as I had hoped I might,

I became exhausted by it, and all I had was a stack of paper, no dog. You can't get there from here.

Again, I don't mean to criticize the act or craft of writing—only to remind myself, as I do several times a day, of the potential imbalance of it, compared to the rest of the weighted world. It's easy to disappear to the bottom of the well and not come back out. It's easy to disappear barking over the horizon. I think most readers want to see writers, artists, charge hard, or move powerfully, or gracefully, out of this world— but then turn and come back to some anchor in that art, whether a physical place, or an emotion, or both.

Here is how he disappeared. It makes no sense to me, given the loose scatter of available facts. I can re-assemble them into a likelihood, or into a combination of possibilities—but out there, beneath the stars of September, there was, and is, only one occurrence, and it is a reality, and unknown to me.

Teachers of writing will tell you to start a story as close to its ending as possible—for compression and power, I suppose, or perhaps operating on the assumption that a shorter length is easier to work with than a long one—but the closest I can get to the end is the day before. (If indeed the end has truly happened. I still continue to hold the heavy hope, expensive to the heart, that one morning I will open the door and he will come bounding in.)

I was trimming brush with the chainsaw in the mist, close to dusk. Elizabeth, my wife, had gone to town with our youngest, Lowry. I had our older

daughter, Mary Katherine, with me. One of the little poles I was trimming leaned over on me, and with one cross-arm movement I pushed it aside, while with the other arm I let the blade, still spinning, bite into my kneecap, sawing down close to the bone.

I bandaged the wound, but it wouldn't stop bleeding, so that night I went down to town and got it stitched up, returning home shortly after midnight. By then my knee was stiff and painful.

The next day I couldn't walk on it much. The doctor had said to stay off it for two weeks, which discouraged me, because the most wonderful time of the year for bird hunting was coming, and I had three dogs that I tried to take out late every afternoon.

I wrote all the next day—Elizabeth and the girls were in town again—and when they came home late in the day, in that beautiful laying-down September gold light, I hobbled out to greet them, and to help carry Lowry into the house.

I took her from her car seat and headed for the front door, rather than the back door, because I would have had to make a little pivot to go to the back, which would have hurt my knee. So I took the long way around. If I had gone in the back door, Colter would have followed me into the house, and all would have been well.

As it was, he followed us to the front door, where he's not allowed in. Carrying Lowry hurt my leg, so I set her down. Colter was licking Lowry and wiggling his bony butt all around, and I stopped and petted him, for which I'm glad, and he kissed Lowry all over

while she petted him. Then, because he was being unusually affectionate, getting in the way, and because my leg was throbbing, I said something like, "Go on, now, Colter," and took Lowry inside, and went back and got the groceries from the truck, and then, for the first time all day went upstairs to lie down for a few minutes to rest and elevate my leg. I was reading a book by Amy Hempel, the great story writer and lover of dogs. The light across the marsh was beautiful—shades and smears of green and gold, with the first week of true autumn fresh in the air. The fields were still green from the heavy summer rains, but the leaves were changing, blowing gold across that green grass, and the light was carrying that coppery tone.

I half-dozed. Then there came a tremendous deep bay from the yard: Colter, once. It was the angry, frightened bark he gives when he is surprised by something—some new sight, or some person walking down the driveway: then silence. I hurried to the window, listened, watched. I saw the old hound, Homer, come trotting back down the drive—saw the pups on their chains staring up the drive—but nothing else. I figured it was a sound out on the road that had startled them. Or perhaps a deer had wandered into the yard, browsing on the lichens from the brush I'd felled the day before, and had frightened Colter, and he'd given short chase. He would be back. He would trot up the road a ways, then turn around, as he always did.

If I hadn't tried to sever my leg the day before— hadn't tried to cut off a part, a piece of me—we

would have been out hunting at that time of day. The world, our world, would have canted differently.

I went back and lay down. It was only an hour before dusk.

How many times, in the field, had the twinings of our paths—his castings, and my pushing forward into the wind—passed just left or right of a huddled, hidden bird, undetected?

Not often, I would suspect. In fact, I would have the boldness of confidence-in-him, the brashness of experience—thousands of miles hiked with him—to say never. Never did he pass over a bird that I would then flush with my passage. I do not think he could miss finding a bird any more than the wind blowing through a forest could miss brushing a tree or a leaf. Once, when Colter was a pup, my friend Jarrett shot a quail over him. The quail tumbled and Jarrett told Colter to go get the quail. He did—Colter brought it back to us, then went right back out into the field and went on point about twenty yards downwind. We knew there couldn't be any more birds in the field—we'd released just that one for him, for train- ing—and when we went over to see what Colter was pointing, we saw nestled in the grass just ahead of him a single small feather that had been torn loose by birdshot and drifted downwind, to the place where Colter had found it: moving toward that single feather, I suppose, the way you or I might follow the footsteps of someone who'd dipped their feet in buckets of green paint before walking across a white floor.

Never before, I believe, had we been canted left

or right of things—never before had we been tilted even slightly away from the head-on pursuit of our desire. I would read him as he charged head-high through the fields, and from that reading we would tilt slightly left or right to better accommodate his responses to those fields of scent.

In viewing our passage from above—from some great distance above—I am sure that our movements would have been intriguing, appearing as natural and yet at times as surprising as the bends of a slow braided river winding across that land.

So this new clumsiness, this awkwardness—this feeling that we were a moment or two out of step with each other, and unconnected, due to the slipping, perhaps, of some gear of fate, or a previously accustomed grace—is unknown to me, and, I am sure—wherever he is, out there—to him, also.

One little thing—one cant left by a degree or two, or a moment or two, or one cant by a few feet to the right—and he would still be with me, and I would not be without my crutch, dispirited, with places in me carved or hollowed by his loss, my loss.

To love a dog like that is easy; you love him with the same intensity with which he loved bird hunting. It was so easy. When he locked up on point so staunch, you could feel the electricity of it, even a hundred yards away—even if your back was turned to him: as if, in the stillness, someone had shouted your name. I certainly didn't know any better than to follow him wide open across those vast spaces, and to love him wide open, as he loved the birds.

And now, as a way of honoring his spirit—that essence of his spirit—I continue to hold out hope that through his deep magic, and this valley's deep magic, he will make his way back to me yet, in some form or fashion unable to be imagined, but which upon completion will seem as unavoidable, as pre-determined as any destiny.

It is a hugely expensive luxury, this holding of hope. Despite being invisible, this hope possesses a density as real as one of those rocky touchstones or anchors of archetype: dog, forest, field, river.

The possession, the prolonged care and nurturing of such romanticism—living and running with a near lack of borders to one's longings—can be like a heart with a too-hot coal resting inside it. A small hole can be burned in that heart, through which other things—stamina, eventually, and other vitalities—will drain.

A good day is when I believe or know he is still out there—that someone was driving down the road and stopped and picked him up, having believed perhaps that they always wanted a hunting dog; and my believing, or hoping, that they will tire of him, or that he will be found by someone else and turned in for the reward.

A bad day is when I believe or know he is less than a mile away, half-buried in the moldering black earth and pungent decay from the leaves of aspen, alder, ceanothus, and cottonwood, shot by someone and then hidden.

I am not so blind in my passion as to not make

the connection that *if* he has met his end at the hands of man, or lion or bear or wolf, to consider then the fullness of his end, if an end has occurred. He who lived as a hunter, dying as the hunted. (I don't believe this to be the case; the other dogs would not have accepted such an event so blithely, nor would Colter; I believe I would have heard at least one yelp.)

I am not blind to the deaths we participated in—hundreds of birds, perhaps. Not a fraction as many as a house cat will kill in its life but, nonetheless, a lot. His teeth on them, those that he retrieved. My teeth on them, later in the winter.

If he is gone from this layer, this level of earth, I do hope it was to a lion or bear or wolf pack, and that his passing was not wasted uselessly upon the whim or anger of a man or woman.

It's hard, not knowing. It's hard, moving across the space where his greatness once was.

The act of turning him out into the fields had the same feel of power or force to it as when you take a chain saw, iron-and-oil, sharp steel, and jerk once hard on the starter cord: the quick burp, then the roar, of blade-and-engine. A rawness of power, total and immediate, leaping as if from nowhere—though of course it was not that way at all; the power appeared from out of intricate order and design.

We can exist, perhaps, without much contact with these archetypal, physical verities—forests, prairies, deserts—these place-sources from which, as a species,

we have sprung, or leapt, as if across a chasm—reckless, confident, and fearless. How incredible it seems, that we have crossed such distance in only a hundred thousand years—or however long our species has been here, upright.

And if all the durable things beneath us—the things from which we came, the things that made us—vanish, then perhaps we can continue to exist, in some humped-over, twisted, errant fashion. But what if the landscapes themselves vanish—shaken empty of their wild, reckless species, and the wild, reckless grace out of which we were poured?

What is vanishing? How do we measure wildness, and decide what needs preserving, both in reality, as well as in story, in shadow?

What happens if we lose our anchors and exist one day only in a world of shadows? As if even the familiarity of mountains in the distance were to become rubble, broken into disorder.

Those mountains on the horizon—both fore and aft—will become rubble anyway, of course; they, and the things in them, will be worn down to hills, then to nubs, then nothing—all washed to the sea, dispersed as loose sand, until even memory is gone.

But must such loss happen within one or two pale generations of humans? Isn't that process—extinction, and total loss—supposed to take millions of years?

What happens when the durable things fall away, one by one, then two by two?

What kind of stories do we tell, as we are falling? And how do we live our lives?

2 The Yaak

The Yaak is two places. You can come around one corner, and understand that you are in the northern Rockies: immense Douglas fir, aspen, cottonwood, Rocky Mountain maple. Four species of pines: lodgepole, ponderosa, western white, and whitebark. There is the scent of old charcoal, dry rock, resin, youth.

But round the next corner, and you are into the Pacific Northwest. Cedar and Engelmann spruce tower alongside the cascades of waterfalls; ferns fight for every shaft of light in the seething understory. The temperature drops twenty degrees. Entirely new scents hit your brainpan: berries, decaying leaves, cold rushing water, moss.

The Yaak is always two things—and from two things, many things, perhaps an infinite number of things. It is both a foundation, an anchor, as well as a link, a resting place for the movements of the biological narrative of this continent.

The valley borders Canada to the north; all of the western United States's wildness lies to the south, already a week or two into spring, while the Yaak still sleeps, or moves slowly.

The Yaak links east and west, too, bounded to the west by the thin sliver of Idaho panhandle, and then by the state of Washington, and then by the ocean.

The Yaak is its own place, as well—doubly fortified. What is rare in the world is still common in the Yaak. The forests of giant larch—tamarack—are the rarest form of old-growth in the West, but are the most common form of old-growth in the Yaak.

What is rare in the world, or beyond rare—all but invisible—still exists in the Yaak; though those rarities have been whittled down to heartbreaking, gleaming irreducibility: as if, were we to be given the chance at a clean slate and another shot at things—as in the days of Noah's Ark, perhaps—we would be hard pressed to find the God-ordered two of everything.

One woodland caribou—a lonely bull, wandering vast distances.

Only twenty or so grizzlies, in this half million acres of national forest—this rubbley mixture of clearcut and old growth, this confusing grid of all-or-nothing. Of those twenty grizzlies, only three are known to be breeding-age females. (For a long time, there was only one breeding-age female; the whole valley's immediate grizzly future hung by that single thread. But now two of her daughters have reached breeding age—it takes six years—and has produced a couple of cubs.)

There is one remaining population of a fish so rare that almost no one has even heard of it—the inland redband trout, a native landlocked salmon. Not coincidentally, that fish lives in the last uncut basin in the Upper Yaak.

Excuse me. I've been writing about the Yaak for so many years that I forgot to mention what the problem is: clearcutting, and the further fragmenting of the last cores of roadless lands on the national forest. The Yaak is the wildest valley in the lower forty-eight, and yet has not a single acre of protected wilderness designated for, or tithed to, the future.

To date, over a million loaded logging trucks have rolled out of the Yaak. I don't know where the money all went.

Only twenty or so grizzlies, but what fine grizzlies they are, sculpted and honed by century's end to fit perfectly the coming century. These grizzlies have the invaluable, immeasurable genes of survivors. They are grizzlies that somehow have—to this point—adapted to, and survived, our ravenousness. The grizzlies of the Yaak have genes that are good as gold for the coming century; these bears run from the sound or scent or sight or even the *idea* of humans. They're not roadside park grizzlies, but the real thing, raw as a secret, shifting and flowing through time, and through the forest: never seen. A track, now and again, in the mud or snow. An enormous scat. A field of overturned boulders and excavated sod, as if the bear had not so much been grazing on the tubers of biscuitroot as instead sculpting with his or her paws the very soil upon which he or she walked—taking dabs and scoops of soil and making things, and re-arranging, resculpting, the skin of the earth to better fit some desires within the bear's heart.

A mountain lion once chased Colter down an old logging road. It was in the summertime and we were just out hiking, climbing the mountain above the cemetery. Colter got a ways out ahead of me, galloping—charging up that mountain, only a year old, but already as powerful as a drafthorse, graceful as a thoroughbred—and after a while, I heard him yelping

excitedly, as he often did when he flushed a grouse by accident.

His nose was forever leading him to grouse.

There was a silence after that. I assumed he was chasing the fly-away bird, an act I hoped to discourage, and I shouted, "Colter, *leave* it!"

I was standing on the slope of the roadcut above the old grown-over logging road. Presently I heard the cyclonic thump-pattering of his feet coming my way, and within a second or two he whizzed right past me, moving faster than I'd ever seen him move. His ears were flopping and his tongue was hanging out and his yearling's long legs were scrambling as fast as those of a cartoon character, and I thought, Man, he really *wants* that bird.

Such was his speed, the fury of his legs churning, that he could not control his flight; he kept tripping over his chin, his body propelling itself faster, it seemed, than his legs, so that he would sometimes cartwheel; though even in his cartwheels he kept cruising along. He raced right past me—"Colter, *leave* it!" I shouted again—and he gave me this wild-eyed look that seemed to say, *What do you think I'm trying to do?*

And then right behind him came the lion, bigger than I realized a lion could be—looking like something transposed from Africa, gold as a grizzly and as large, so that at first I thought that's what it was, head as large as a basketball, and huge-shouldered—until I saw the long tail floating along behind it.

It was easily twice as large as any lion I'd ever

seen. I read later that occasionally males can get up to around two hundred fifty pounds, so I guess that's what this one was, though, in the shock of the moment, I would have estimated the lion's weight to be about six hundred pounds. He glided past me with a strangeness of locomotion I had never seen before—it was as if, with his long easy strides, so slow compared to Colter's churning *rpms*, the lion was floating, drawn along on some magic carpet. Looking slightly down on the lion from the road-cut embankment, I could see every huge muscle working, reach-and-pull.

The lion was gliding right behind Colter, like some huge floating Chinese dragon in a parade, or a lazy kite string at the end of the furious dynamo of Colter. At any moment it seemed to me that the lion could have reached out its big paws and pulled down this small brown screambug rocket of a dog, but the lion seemed to be made momentarily curious by the little twitching nub of Colter's tail.

The lion passed right over my shoe tops. I could have netted him with a six-foot dip-net. There was some shadow-part way down below me though not at my core that weighed the option of being silent and still and letting this thing play itself out and maybe, maybe, everything would somehow turn out okay—but it was just the dry shell of a consideration, having no more life to it than the husks of insect skeletons you find clinging to the sides of buildings in the early summer, and braided into the nests of birds.

A boy loves his dog; a man loves his dog. "Hey,"

I said to the lion, or something like that. It was only half, or three-quarters, of a shout. "Hey, *asshole,* leave my dog alone."

The lion glanced up at me, clearly surprised as it cruised past, but kept on gliding. Dog and lion disappeared into deep grass twenty yards away—there was a single yelp, then silence—and I could see through the tall green grass the motionless shape of that big lion.

I was afraid he had Colter down—had perhaps broken his neck with one swat—but I held out the thin hope that Colter was only in shock, and that I yet might somehow be able to claim him and carry him, entrails trailing, down the mountain and into town, and get him stitched up and doctored and put back together again.

I picked up a chip of shale about the size and density of a deck of playing cards and advanced slowly toward where I could see the lion in the grass.

The lion turned and looked at me, and my first and immediate realization was to understand how easily one of these creatures could, by itself, kill a seven hundred-pound elk.

My second impression or realization was that the lion was staring at me with perhaps the purest distillation of scorn I have ever encountered. Still I advanced, yelling at the lion, trying to work up a bravery and anger that just wasn't there, and which, I could tell by that cat-scorn look, the lion knew wasn't there.

But I could see the lion thinking, too. I could tell that there was just enough uncertainty about things—

the surprise of my appearance into the equation—for the lion to be wondering if he had not somehow blundered or been lured into a trap.

The evidence before him—a pale, trembly stick-figure advancing upon him with a lone handful of dirt-rock, then pausing and staring at him—clearly did not support this hypothesis, but that was the only thing in the world I had going for me: the uncertainty, that brief revelatory surprise, of my unplanned appearance. I hoped that to such an able assassin as this big lion, the lack of control in any area of his mission would be grounds for cancellation of that mission.

I stood there, gripping that dirt-wad, calling the lion names—hurling words at him. He did not look away from me, nor did the degree of his scorn, the intensity of it, lessen.

I saw my dog! As if only now coming into focus, I saw Colter sitting on his haunches, knock-kneed and spraddle-legged, panting, tongue hanging out. If *scorn* was the lion's essence, in that moment, I would have to say that *bewilderment* was Colter's.

I grew up in Texas, reared as a child on the Fred Gibson stories of noble dogs such as Old Yeller and Savage Sam. For long moments I entertained the belief, the longing, that under no circumstance would Colter let anything happen to me—that now that he was turned around and had the situation figured, he would in no way let that lion attack me: that he would do whatever it took to protect me. Me, the one who fed him and protected him.

The three of us formed a long, flat dangerous triangle, with the lion at the apex. I called to Colter, whistled for him to slink past the lion and come stand by my side, so that we could make a stand, two against one—or better yet, to get the hell out of there—but Colter only looked at me with that same panting incomprehension. He just sat there, looking goofy, and with the heavy awareness of the responsibility of adulthood, I realized that not only was I going to have to take care of myself in this fracas, but of my dog, too.

In the end the whole business was just a little too weird for the lion. After more scowling, he turned and walked off into a dense tangle of blowdown lodgepole—the bulk of his body taking up as much of that little logging road, it seemed, as a tractor-trailer, and yet after he was gone, he was really gone—vanished—and when I went over to collect the panting brown sack of my dog—I had to lift him as if gathering up a limp stuffed animal—I peered into that jungle of blowdown lodgepole, fully expecting to see the lion crouched in there, repositioning himself and recalculating for a return attack.

But he was gone forever, gone from our lives anyway, though for the next couple of years stories would come from off that mountain of other hunters who'd had encounters with him. In future years enough stories would come from the same area so that it was not even like a myth but a certainty: if you went to that spot on the map, that lion was going to fool with you. God knows what he ate: mule

deer and elk, I suppose. One hunter even had several little *cubs* chase him in that area; surely those cubs were the big lion's progeny. They were so young they were barely able to run, but came snarling and spitting at him anyway, little kittens. That hunter left, too.

Another time the big lion snuck up on an elk hunter, who turned and saw the giant staring at him, crouched, at a distance of about five yards. The hunter hurled a hatchet at the lion and struck it—like tossing an empty aluminum can—but the lion turned and ran back off and disappeared.

He hasn't been seen, or noted, for a couple of years, but it's hard to believe he's not still out there. Though maybe, too, he was already old when all that was going on, so that now, soon enough, he is motionless, with that big basketball of a skull gleaming bright on a hillside somewhere, bone-sharpened teeth pearl-polished and still open as if protesting or snarling at even the rising and setting of each day's sun. The lion's long ship of bones relaxing and slipping now, dissolving from its previous order—a vertebrae or two tumbling down the hill, a femur rotating awkwardly in a way it never would have in life.

But even in that repose, even in that transition from full-muscled grace to loose-boned chaos, I think a grace would return to the magnificent old lion. I think yarrow would bloom through one of the huge, perfectly round eye sockets one year. In the case of that lion's magic, anything is possible to imagine: maybe twin yarrow, from each orbital, or

twin penstemon, like prayer flags in the wind. As if those bones were incapable of being disassociated from grace or beauty.

Perhaps for a hundred years, or longer, deer on that mountainside would avoid even the location of those bones—as if believing they might yet re-assemble themselves and leap up again into head-long gigantic flight.

We have no sure way, really, of knowing any-thing. Our hearts and the blood of the millennia that those hearts pump know so much more than what we can read or experience in a lifetime. A mountain is like a library.

What I suspect happened with Colter and that lion—though I cannot be sure, can only guess or imagine it—is that Colter, with his excellent nose, caught wind of a grouse, and was working it, and got to it at the same time the lion was stalking it, and that the grouse flushed; and that the lion, angered—and surprised—chased Colter.

Quivery legged, afterward, Colter and I hiked on down the mountain, glancing over our shoulders often.

We passed through the cemetery on the way to where the truck was parked: passed beneath those shady, ancient tamaracks.

He was one year old, that year.

Such lush, dripping diversity, here in this land-of-two-places, and where the force of it, that diversity, some essence in the air, contains more power than

the sum of the parts—again, one of the unprovable, ungraspable elements of magic. I believe magic in a landscape can be that simple: a place that still retains all of its graceful fitted parts. And that one of the reasons we find magic in such thin supply these days is not because of excess or overaccumulation of knowledge, but because so damn few of those places still exist in which magic can find a healthy medium: where magic can prosper, and get up and move around.

I'm terrified that the loss, the slippage, of even one or two of these elements in the Yaak—water howellia, shorthead sculpin—can lead to a diminution of the magic; a vanishment, a disappearing.

Certainly, out of such a belief or suspicion, it would be easy to see the attraction art—especially, to my way of thinking, literature—could hold for a person. You could recreate, with the little cages of words and stick-letters, approximations and models of that vanishing world above and below, and all around. Words like square little vertebrae. Even if the grizzly bear was gone from a place, you could have, for thin solace, the words *grizzly bear;* and though the words would not possess a fraction of the emotion of the real thing, they would carry like a shadow or a memory at least—for a while—some residual taste of the creature, the source, of those words.

Again, how humbling—the electric pace of that diminution. Something, someone, created the mountain. The mountain created the grizzly.

Someone created the words *grizzly* and *bear.* The

writer borrows these two words as a squirrel borrows a fir cone, caching it here or there, for a little while.

I understand, I think, the impulse, if that is what it can be called, to write about the natural world, as a means of preserving and paying respect to its shadow, its memory. But I understand also how tiny that act is, compared with, say, protecting a mountain, or two mountains, or a string of mountains, like vertebrae, or sentences.

In a story or an essay, there is the brief strange comfort to the soul, at least, of having protected, kept alive, or even enhanced the shapes of those things—the shadows of sculpin and howellia—if not possessing the actual sight of them. But that is really a thought for the art section of this essay, not the Yaak section. There are in any writer's life all these overlapping shadows—family, of course, and the usual various passions or avocations, as well as, usually, some stored body or reservoir of knowledge or experience—and there is also the large and solitary shadow of craft. And, with some writers, there is also the shadow of activism.

Throughout any given day these shadows are swirling around in the writer like the movement of sunlight through the green leaves in an old forest— or like the shadows of a flock of birds passing overhead—though for this essay, I'm trying to pause and separate them into four sections—even if only for a few moments.

For some reason unknown to me, I'm not really comfortable doing this. You'd think it would feel

good to dice them—the components of a life—into quadrants, like the four points on a compass, and break them down and analyze them one by one. Colter, the Yaak, activism, art. But I like them swirling all past with their fast-swooping, seemingly erratic motions. I like the whole mash of it braiding like rivers of scent, intoxicating, and washing past.

I get scared and lonely, off balance, when I dwell too long, focused solely in one compartment. You tend to light yourself on fire for these kinds of things, which I think is great—that magical incandescence of committing totally to a thing, and blocking out all else—but they don't call it burn-out for nothing. If you stay down in one of those other zones too long, when you emerge it can feel as if the whole land-scape around you has vanished to char—that real life has passed on—and that you are covered with soot and coal yourself—that you are a black beast, altered, and are no longer of any use or function or capability among the soft fleshy world of humans.

It might have been great fun, being down at the bottom of that well, that fire-hole, but now there is a price to be paid for that fun, that incandescence.

So even though the bird hunting, and the beautiful mountains, and the activism rob directly from my art time, I acknowledge also that they save my ass in the long run.

If there's a crazier group of people out there beyond artists, I don't want to know about them.

You never hear, for instance, about bird hunters sticking their heads in gas ovens or leaping off of

ships. Nor are activists particularly prone to that behavior. (I'm not saying they're particularly fun to be around—but they seem more grounded; they seem better at staying alive, so that they can continue trying to learn the lessons of *how* to live.)

Every artist fantasizes about shedding his or her anchors. We fantasize about the added energy and concentration we'd have; about how much more brightly we'd burn, without all the other obligations.

And perhaps we would—for a little while. But it is such a short road, in any event, that I am not sure a little attenuation, and a little meandering—a little banking of the coals, at certain times—isn't, well, *prudent*.

There are times to roar too, of course. But you can usually roar better if you're rested. You can burn a fire hotter, brighter, longer, if you've spent time gathering more fuel instead of tossing on one twig at a time.

But now in this essay I've gone way over into the writing section already. Too far; too aswirl. Too much meter, rather than the direct measurement of a thing.

There is this phrase I use—used—with Colter, when he would run too far afield—when he would disappear over a rise, or, sometimes, the horizon. I'd keep on walking, hunting alone now, and eventually he'd come galloping back in, acting like he'd gone that far on purpose.

"Where have you *been?*" I'd ask him, disapproving—and such was our bond that strangely, every time, I'd expect an answer, though every time—

"Where have you been?"—he did not answer, unless it was with that laughable, shit-eating grin, ear to ear in his big hound's skull; and he'd strike out hunting again, back on track, as if no mistakes had ever been made, and I'd think, *What the hell, I guess he saw some country.*

This section, this chapter, is supposed to be about the Yaak: about the importance of those last roadless areas and about the kind of people sculpted by the presence of such places.

We are so used to viewing the land and its resources as raw materials, and ourselves as the tools, the machines, the sculptors, that we have forgotten how it used to be the other way around.

A certain kind of blade is going to produce a certain kind of cut from the hand of the sculptor. A certain kind of medium—tough, malleable, dense, brittle—is going to yield a certain texture beneath the scallopings of that blade.

We are soft, pink, almost hairless—more malleable than clay, and as adaptable, almost, as bacteria. The landscape carves at us with wild abandon, artistic glee, even if we do not notice.

But in a place like the Yaak—where the landscape still has its full set of tools, its full empowerments—where nothing has yet been lost—you notice.

Community. Besides the one occasional caribou, the five wolves, the twenty grizzlies, etc., there are about 150 people living here year-round. (Seven or eight people per grizzly. I'd personally like to see the ratio

more closely approximate one, and think that in some crude ways that ratio might be as good as any other at determining the ecological health of a place.)

Before us, the Kootenai people used the valley for autumn hunting and berry-gathering, but kept their permanent camps down at the valley's perimeters, up and down the Kootenai River, where they were more of a salmon people, associating and trading with the other tribes of the Northwest; though they would cross over the valley and the glaciers of the Continental Divide once a year, and hunt buffalo out on the prairie. Even then this place was a wild link between east and west, and north and south.

Whenever I stand on a mountain here and look down at the north-south plunge of canyons, the folds of deep green and blue, I think of the long claw marks the bears leave on the trees up here, in places where they mark their territory by standing up and stretching: raking their claws vertically down the trunk.

I see where the glaciers once stretched taut across the bowl of our valley—carving with claws of ice those canyons, those gouges, as equally spaced as if from the claws of a giant ice-bear—and I feel a deep love for the valley, a deep sense of belonging, and wonder if the rocks and soil feel that love for the glaciers—for the movement of time and ice—and if the forest, the trees, feel that love for the bears. I do not see how it can be avoided: the attachment of that fit, the mold of that sculpting.

We all feel a great love for this place: all one hundred and fifty of us. It's why we're here. As with the

notion of the 1-to-1 grizzly-human ratio for estimating ecological health, so too perhaps exists a ratio for determining the health, or vitality, or, hell, call it magic, of a human community: the percentage, the ratio, of residents who have chosen to live there—to commit to a place—despite the fact that we could earn far more money elsewhere. Call it 90, 95 percent of us, and then throw in the fact that it's not rich folks deciding to take this invisible pay cut, but poor folks, and the magic meter, the health meter, goes way up.

A fierce pride develops—a pride of self and place—and even an ornery pride and appreciation for your neighbors; even for those whose politics or values you might disagree with 100 percent, as a balsamroot might disagree with deep north shade.

Inherent from the beginning in such an existence, such a commitment, is the existence, the creation, of a balance. There is from the beginning a give-and-take in the equation. The humans have already laid something down on the table—have anted up—before being dealt their hand. I cannot help but believe that the landscape appreciates, or at least respects that gesture—perhaps no more significant than the direction of a breeze down a canyon, brushing against stone, but real, nonetheless—and I know that we respect it about one another, even when, say, one of us wants to protect the last little roadless cores, these last little anchors of ecological integrity, for all time, while another of us, say, believes that trees are no more than a crop of fiber to be harvested and controlled and rotated, again and again, like corn or

wheat. That it is all but a kind of gardening, and that there is great glory in that work; and that there is disturbing sloth and chaos, even un-Godliness, in places where this kind of work is absent.

I see the protection of these last little islands of untouched wilderness—there are only thirteen of them left in the valley—as a kind of gardening, as well. It's simply that what is produced from those untouched gardens is invisible, immaterial, immeasurable— though just as important, and just as nourishing.

What they produce, year after year, from not being touched, not being weighed and measured, contains the very essence of the thing we all felt stirring within us when we made the trade to come up here.

There is an age-old dynamic of give-and-take—of people sculpting a place, like a nest to live in, and of the land sculpting, creating, our soapy-soft selves— our lives, our cultures, and even, perhaps, our souls. Perhaps such sculpting goes right to the edge of our souls, to the skin of our souls, but then no further. Or maybe it goes all the way, in the manner of the sky sculpting a mountain: mountains appearing where before there was only sky, and then new sky appearing where before there had once been mountains.

This mixture of give-and-take, rather than simply all giving or all taking, provides balance, stability, durability, over the long run, as does any form of diversity. The old Bible lesson of creation: two things are better than one. Two things, not one thing, are necessary for life.

The wild Yaak is an island—stranded in its great beauty and strangeness between the vast ocean of stone that is the northern Rockies, and the diminishing ocean of timber left in the Pacific Northwest. And, as is the case with island inhabitants, most of us drifted in here as seeds: drawn by tides and winds or carried in the fur or feathers of another—a friend, a relative, an acquaintance, telling us of this place, or accompanying us. *Colonization.* It's such a new place: the land meeting full-time human residents for the first time ever. The first homesteaders moved up here only this century. Compared to other places, there is little human history; compared to other places, no deep history; instead, history is still happening.

Which is being carved faster—the community, and our spirits, our culture—or the land?

How to behave—how to live, how to act—in a way that can sustain this newness? How to sustain and keep that awe vital? Surely the answer lies in the notion of balance: that any time something is taken, something must be given back.

Even at its nearly irreducible core—its geology—the wild Yaak is unique. The other valleys in this region received nearly complete glaciation in the last Ice Age, while the Yaak—the lowest spot in the state—received only about 70 percent scouring. So in some respects the Yaak is very new, while in other respects—the measurements of stone and wind—it is very old, possessing beneath and within itself a memory more ancient than that of any of the lands now at the surface.

How to act in a way to avoid excessively tarnishing our own newness upon this place—to avoid wearing out our welcome, and wearing out the skin of the land, as we have done elsewhere—and tarnishing also, or losing, a thing in our spirits, as has happened amid so many other landscapes?

There was—and, if he is still out there, is—something radically different about Colter. Anyone could see it, when he was hunting, whether that person had ever seen a bird dog work before or not—but people who hunted could especially see it. It amazed them every time—that fire, the ignition of that switch, from sweet sleepy brown hound dozing in the sun to cat-lightning-with-his-ass-on-fire. Then what would amaze them even further—once the outer limits of physical amazement had been transcended, following the brief ripping fury of Colter's passage—grass seedheads and snowberries-like-pearls popping in his wake, and a forty-mile-per-hour swatch cutting a giant Z through the brush—was not that it was some creature down in the brush moving that fast, but rather, as if the field, or the brush, was doing something of itself—some kind of demonic omen, an uprising, a revolution from the spirits of the brush. . . .

What amazed the viewers beyond the physical sight of him was the knowledge that he had come directly from this strange, dark wet forest. Traditionally, the great shorthairs are all accounted for. They're line-bred, sired and dammed and whelped out in the

bright sunlit pheasant fields of the Midwest. And here was this throwback, this dinosaur, bred by an old falconer/rodeo cowboy and his wife: the dog as fierce and dark and strong and different as if he'd not been born but had emerged from a hole in the ground, a cleft in the rocks. Whenever anyone asked, as they always did, again and again, *"Where* did this dog come from?" I would get to tell them. "A big country makes a big dog."

And people who would not normally listen to such seeming platitudes, people who would instead reject such statements automatically—having been shaped and sculpted (and, who knows, perhaps bred) by our economic system over the last forty or fifty years—would, on the face of the physical evidence before them—the only kind they believed in any more—have to consider that.

If they watched him for more than a few minutes, they would become mesmerized, and would believe: would have to believe. And in that time, I noticed— during that time—those people, such people—oil company executives, attorneys, et cetera—would be made happier, as if something previously lost had been returned to them. You could see it in the way worries and other accumulations around their eyes re- laxed. You could see it by the way all the muscles in their face relaxed, and then all the rest of their body. Standing next to them, you could feel their lightness of heart.

This metamorphosis would not last, of course. In fact, it would vanish as soon as they left that real

world and went back out into the other world, where they would be sculpted and formed back into their usual shapes. Perhaps they might carry with them for a little while some scrap of the memory of that feeling they'd experienced, watching Colter run; but whether such a scrap, buried far within and beneath so much clutter, would have any more value than, say, a faded old laundry ticket in the pocket of a coat found years later, I could not say.

He was a witness, an ambassador. As I think we all are—as we cannot avoid being—for the place where we come from, the place where we live.

There's this great old hand-hewn log cabin church up here, set way back in the old woods. It serves also as our community center. I'm not sure how old the church is. It looks like the ceremonial longhouses the tribes in British Columbia, and the rest of the Pacific Northwest, used to build.

Our community had a little meeting there this last summer. I'd written a slim nonfiction book, *The Book of Yaak*, which entreats for the protection of the last little islands of roadless wildlands on the national forests here in the Yaak. The book makes the case that there is little harvestable timber in these last roadless cores anyway (that's why roads weren't put there in the first place)—that it would be too expensive to the taxpayer if we did try to build roads there—and that these places would have far more lasting value to us if kept forever as the wilderness they presently are.

The book makes the case that it is usually in these roadless cores where our threatened and endangered species find sanctuary, and it makes the case also that mystery is to be found emanating from these roadless cores—radiating outward from them, then, throughout the rest of the valley, and even pulsing across the rest of the region. And that such wildness is a source of strength.

For a long time, I'd been asking for wilderness protection for these cores. There's not an acre, not an inch, not an ounce of protected wilderness here, despite the fact that the lands are 97 percent public. The timber industry's been treating them as if they're 97 percent private—*theirs*—and I criticized the ongoing liquidation, its unsustainable nature—which annoyed a lot of the people making short-term profits from that liquidation of our shared lands. These folks spread the rumor that I was against logging, which I'm not; I *want* logging to continue up here, to help this place keep its identity and rough character. But if the forests are lost, we'll lose even logging.

The rumors spread further: that I had a secret agenda of gaining wilderness protection for these little islands first, sure, but that then my next desire would be to evacuate everyone from the valley—I'm not sure where they thought I'd figure into this; I'm kind of attached to the place—and turn it into a national park.

In the meantime, however, some other folks decided they liked the idea of protecting those roadless cores, and these folks decided to form a little

group to formally request that those last areas, last cores, be kept roadless in the next ten-year forest plan, at the very least.

We're calling our group the Yaak Valley Forest Council (YVFC), and we're a pretty representative mix of valley residents: hunting and fishing guides, bartenders, massage therapists, roadbuilders/heavy construction operators, writers, seamstresses, painters, construction workers, nurses, teachers, botanists, loggers, photographers, electricians, carpenters.

Like no other place I've seen in the lower forty-eight, we all draw our sustenance directly from this land. We draw it spiritually, every time we step outside and look up at the mountains, or even when we look out the window, or even—especially, perhaps—when we close our eyes and sleep at night, knowing the wildness is still out there; and we draw our sustenance from the valley directly, physically, as well. We cut our firewood from the forests; we gather berries, fish, grouse, mushrooms, venison from the forest. We garden, gathering its heavy rain and brief sunlight. The wildness sustains us. We are all here and not somewhere else, because we love the valley the way it is.

So we had a town meeting, to try to explain things. There are about forty-five of us in the group. (Some of us are for wilderness protection, while others are uncertain. But we all agree we want those last roadless cores to be kept roadless: for those areas to be left to proceed at their own pace: to burn, or rot, or grow old—to be wild. To let that last little bit, at least, be wild.)

We currently have nothing protected. We are asking only for a little: for things to stay the way they are, as much as possible. But you would have thought we were asking for the whole shittaree.

We'd envisioned a quiet, informal town meeting where we explained our needs. But the opposition panicked, I think, and brought in industry folks from the towns of Libby and Troy, forty miles away. Forest Service folks came, as did county commissioners and state representatives.

In the end, I think the meeting went well. People got to get up and speak their fears, their beliefs. One fellow got up and pointed to me and said, "There is here in our midst one who . . ." I forget exactly what the rest was about me that was dangerous, but it wasn't good—something about the United Nations and social engineering, I think—but we all got to say our piece, our opinions, which is how democracy, as I understand it, is supposed to work; and despite taking a pasting, personally, and being accused of wanting everyone to have to abandon the valley, etc., I felt great relief and optimism, afterward, as if bottled-up voices—some just beneath the soil, some from up in the high branches of the trees, and others from along the river—had braided together that evening and found an avenue by which they could be heard.

And what scrap, what memory, did people carry away from that meeting? Perhaps more than scraps.

We intend to have more meetings. We need to have more meetings.

But once again, in trying to focus this section on the Yaak—the landscape itself—I have crossed

boundaries I'd laid down previously, boundaries that I had intended not to cross: veering over into the activism, again. And yet, again, the next section—activism—shadows the movement of text, of narrative, always. Sometimes the creating of a text feels to me, as a writer, like a thing getting up and moving, coming to life. The writer following that thing, tracking it—sometimes pushing and pursuing it, other times coming upon it quietly, as the thing rests—but always behind it, always following it, trying to define and discover it.

One last thing about the YVFC, nonetheless.

What amazes me most about the formation of this group is that absolutely none of us moved up here to be joiners of any kind. We all drifted onto this island to move away from some things, while seeking others. But activism, and political engagement, would have been at the rock bottom of any list. Much of the valley has no phone service, no electricity, no *infrastructure*. To be blunt, we moved up here to be quasi-hermits. We stepped into these dark old woods—we committed the rest of our lives to their quiet embrace—in large part to avoid being seen so much.

And the landscape has taken that tendency, that yearning, and has only refined it further.

So for a big bunch of us to form a group, an activist group—no matter how simple our one goal— well, I don't know quite what to think about that. Part of me is pleased, but another part of me worries that things have gotten so out-of-hand—the century's

push to destroy all remaining unprotected wilderness—that it's become necessary for even hermits to band together and provide a common voice.

We meet irregularly—we have no officers—and all decisions, what few there are, are made by consensus. All voices are equal, and we will leave no one behind.

We are nothing but a response to a disturbance in the landscape.

We await the sculpting blades daily, rise with great joy at being able to be one of the fitted elements of this place, and trust intimately the hands of the sculptor, the artist, or force, which is plying that blade.

Here is a list of some of the threatened, endangered, and sensitive species in the Yaak Valley, many of which rely hugely upon the security of those last roadless cores: bull trout, gray wolf, woodland caribou, grizzly bear, wolverine, lynx, fisher, harlequin duck, golden eagle, bald eagle, torrent sculpin, sturgeon, Coeur d'Alene salamander, great gray owl, Westslope cutthroat trout, flammulated owl, shorthead sculpin, northern goshawk, boreal owl, peregrine falcon, wavy moonwort, Mingan Island moonwort, Townsend's big-eared bat, small lady's slipper, common loon, sparrow's egg lady's slipper, kidney-leaved violet, maidenhair spleenwort, black-backed woodpecker, round-leaved orchid, green-keeled cottongrass, bog birch, crested shield-fern, Spalding's catchfly, linear-leaved sundew, northern

golden-carpet, northern bog lemming, water howellia. . . .

There are more, of course—a Noah's ark of diversity in this magical, totally unprotected wilderness—lions, moose, elk, bobcats, black bears, geese, grouse.

I love this wet dense place. It's nothing but mosquitoes and dripping leaves, deep snow, and heavy rain, hissing rain, and mud and dense jungle. I don't know why I love it. I don't know why I love it more each year.

3 Activism

Art gives. Activism doesn't give; it takes. In literature, for example—in fiction, certainly, and in the best nonfiction—you're trying to present an emotion to the reader, trying to make the gift of a well-shaped story: a thing of beauty, which possesses a shape, a heft, nearly as tangible as if you had carved and sanded something. Many writers speak of a story or novel as being like a house that the reader enters, passing from room to room, going upstairs and downstairs—but for me it is more like a sculpted piece of wood; sometimes light or heavy, dense or dark, smooth or rough, tapered or angular. . . . I like to look at, and touch, the elegant carvings of duck decoys, motionless with their luminous agate eyes, appearing so real that it seems at any moment—the moment you turn away—they will leap into flight. And that once you place a series of them out in their native habitat—a pond, a marsh, or river—other ducks, the real thing, feathered and alive, will circle in the sky and begin landing in great rafts.

Is the magic in the artist's hands? Is it in his or her mind? Or is it already inherent in the material with which the artist works?

You do not set out, I think, to carve a duck that will take a duck from the sky. The carving would be step one, and the taking of the duck would be step three. I think you set out only to carve a duck that will look like a duck.

What's debilitating about activism is that you know from the very beginning what it is you're asking for. You know the end simultaneous with the beginning. The odds of that passage being a journey of discovery—for either you or the reader—are stacked heavily against you. You can go through the motions of casting left and right—of attempting to create a sinuosity, a life, to the passage of the text, and you can sniff out little unexplored pockets, but the line-of-narrative is already pretty much set out before you. There's limited opportunity for the natural lines of movement that can create, to my way of thinking, the most dramatic and powerful forms of narrative, and which can lead to a piece of writing possessing the feel to it that teachers of writing refer to as "organic," or, simply, "alive"; and whether fresh or rank, no matter—*alive*. Or as alive as art can be.

That organic quality is why a novel can stay on a shelf for a hundred years or longer. It's one reason you're hard pressed to find, say, a copy of a newspaper article on the Teapot Dome Scandal, or even a still-circulating 1976 magazine article about the ruination of the Everglades. It's not that the writer's talents were, or weren't, sufficient to endure. It's instead the fault of the narrative drama, or lack thereof, inherent in a piece of activism, in the telling of a story.

There have to be exceptions, of course. But I can't think of many. I think the truth is that it might be that simple: that art and activism are as different as stones and ferns, or even clouds and earth, or give and take.

I can see how the metaphor of a house-as-story would work. For centuries, the Japanese have been teaching that a house and its contents can shape a life lived—as sure an act of art, on a lesser scale, as a landscape shaping its species and their cultures. And we have to remember always, I think, in comparing art to activism, that even the most supple and organic art is still just that—artifice; the shadow of landscape. I'm reconsidering that duck decoy metaphor. Even the carving of an exquisite blue-winged teal, for example, can be more like a challenge of technique and craft—certainly with some soul or spirit thrown in, but still relying heavily on technique. Real art, I guess, or real magic, might be this:

What if you were to carve or sculpt some creature from the imagination, something that to your way of thinking might fit the surrounding landscape—a white mythic bird, say, in a landscape of gray stone and snow—and set that carved bird out in a field or marsh, and *then* had flocks of similar birds appear from out of the sky—birds that had never been seen before?

And who can say? Carve or shape such a bird, using your whole heart, and your whole mind—set it out there, give it to the landscape—then sit back and wait ten or twenty thousand years, and maybe one day one of those birds will rise from the clay and the dust and the rain and the wind and appear, settling down into that field, with the fit of lock-and-key, or river-and-canyon.

Do the hands prophesy the motion of the land—the shapes to come? Do stories prophesy the movements of things to come, as a downcutting

river prophesies the shape of the river to come, the river below?

Or do rivers, and hands, cut down through the old draped and folded layers of sediments to tell and retell the kinds of stories that had already played themselves out long before we arrived?

Where does this leave the activist? Are all battles like all stories, in that they follow the models of the past?

Activism takes; art gives. No one has stated it as eloquently as Thomas Merton, who wrote:

> . . . there is a pervasive form of contemporary violence to which the idealist fighting for peace by nonviolent methods most easily succumbs: activism and overwork. The rush and pressure of modern life are a form, perhaps the most common form, of its innate violence. To allow oneself to be carried away by a multitude of conflicting concerns, to surrender to too many demands, to commit oneself to too many projects, to want to help everyone in everything is to succumb to violence. More than that, it is cooperation in violence. The frenzy of the activist neutralizes his work for peace. It destroys his own inner capacity for peace. It destroys the fruitfulness of his own work, because it kills the root of inner wisdom which makes work fruitful.

Any artist's instincts will tell him or her that activism is very dangerous. My intellect tells me it is dangerous, and my experience tells me it is dangerous.

During those rare lovely stretches of a few weeks, or sometimes even longer, when I'm able to set activism aside for a while and work solely on a story—a piece of fiction—the days and nights are imbued with a grace and a dreamy quality and rhythm that is addictive. I can tell that my body needs it: to imagine, and tell, stories.

I love having the freedom, the opportunity, before going to sleep each night, to set out in my mind—as if clearing a place at one's desk or table—a space with nothing in it, for what might or might not happen in the story the next day. And to let that space rest, then, as I sleep, so that it and I are in rhythm the next morning. It is a warm feeling; a snug fit of body-to-bed and mind-to-sleep—preparing, in one's rest, for the next morning, and then the next day in this manner, and the next, until the piece is created, and seems alive to you, as alive as it can become.

There are few beauties like the one of having prepared in that manner the night before, and awakening, eating breakfast, and then walking out to the cabin the next morning with the availability of so much space in your mind. The vast beauty of the landscape around you, despite its magnificence, is only a backdrop, compared to that space and opportunity in your mind—the landscape in this manner a secondary or buried rhythm, or at the most a complementary rhythm, powering your story, yet unnoticed, or barely noticed. Those are the sweet days, when you are lost.

There are also those frightful mornings, however—

hundreds each year, like clouds of black houseflies descending upon sunlit fruit—when I am up late at the computer and finish the day, or rather, the night, by typing a grant to get into the mail against deadline—six or eight or ten pages pleading for a thing that's probably not going to happen—and mornings, too, when I roll out of bed and go not to the cabin but straight to the computer and fool with the damn E-mail and faxes and newsletters. There are mornings in which phone calls have to be made, cannot be postponed, mornings in which you are sorely tempted to say, "Ah, fuck it all," and storm out to the cabin, choosing your art first—believing, accurately, that it's more important—but always in those moments you have to ask yourself also, "All right, am I really serious about this—about wanting to help protect the last roadless areas—or am I just fucking around, working at activism when I want to, and when it's convenient for me?"

It is like nothing but a high-powered saw swinging errantly, unpredictably, in all directions—even though you are the one who is holding the saw.

This essay, for example: all year long I have been working toward October, shoving things into place, tying off knots, snipping loose ends, stacking boxes—clearing a space for October, slow October, in which I could work on one short story—just one—all the gold lazy month. Working toward the wedge, the sliver of perfect October, in the space of time after which summer's visitors have left—we

had 144, between May and September, last year—and before the earnestness of November's big-game season begins.

Yellow aspen leaves, yellow larch needles, gold cottonwoods, blue sky, geese flying south . . . I was going to anchor myself in the cabin by the fire in the woodstove and dream a story, one story. I'd been looking forward to it all year. I had no real story in mind, but was fairly hopeful that if I could make the space, then I could go into that space and find one.

But then the opportunity to do this essay came up. I can't tell you how much I was looking forward to doing a short story—and a short story in October, nonetheless. But to pass up a chance to try to help the Yaak's last roadless core? To try to help those wild places in the Yaak, which is more beautiful and complex, more crafted and mysterious—and nurturing—than any short story? Like a glutton, I bit again.

There's this lovely poem by Ruth Stone, entitled "Laguna Beach," which concludes, "Nature says yes to everything." But perhaps more appropriate, with regard to my own confused discipline, or lack of it, would be this passage from Osborne Russell, who between 1834 and 1843 wrote, in his *Journal of a Trapper*, about the wolverine (also called the "glutton"):

> This Species of animals is very numerous in the Rocky Mountains and very mischievous and annoying to the Hunters They often get into the traps setting for Beaver or searching out the deposits of meat which the weary hunter has made during a toilsome days hunt among

mountains too rugged and remote for him to bear the reward of his labors to the place of Encampment, and when finding these deposits the Carcajou carries off all or as much of the contents as he is able secreting it in different places among the snow rocks or bushes in such a manner that it is very difficult for man or beast to find it. The avaricious disposition of this animal has given rise to the name of Glutton by Naturalists who suppose that it devours so much at a time as to render it stupid and incapable of moving or running about but I have never seen an instance of this Kind on the contrary I have seen them quite expert and nimble immediately after having carreyd away 4 or 5 times their weight in meat. I have good reason to believe that the Carcajou's appetite is easily satisfied upon meat freshly killed but after it becomes putrid it may become more Voracious but I never saw one myself or a person who had seen one in a stupid dormant state caused by Gluttony altho I have often wished it were the case—

When I was living in Mississippi, working as a geologist, I quit my job one day and decided to work for myself—to be a consultant, and to generate maps, prospects of hidden lands, buried landscapes. I was living in a farmhouse way out in the country, in the hills, at the edge between forest and grassland, and was starting to fool with writing as well as geology.

I turned on the radio one morning and heard an interview with Thomas McGuane. I was working on a geological map while he was speaking, but I haven't forgotten what he said. He said that "all literature is about loss, or the recognition of loss." I don't remember if he made that up, or if he was relaying something that Shakespeare said.

I stopped tinkering with my map and considered my favorite books, trying to disprove him. It seemed like a shitty thing to say or hear, especially first thing in the morning, but he was right. Still, I kept fighting the notion, trying to pin him, like a wrestler, into being wrong—I got up and went over to my bookshelf and examined the books one by one—but he was right.

I focused back on the interview. He was still covering ground—speaking these elegant sentences the way most people might labor to carve them with pen onto paper. He was saying that in the case of a story that recognizes impending loss, that of itself can be, even if in a bittersweet way, a kind of celebration—that stories didn't all have to be weeping and lamentation.

Other things started happening for me around that time. I read Jim Harrison's "Legends of the Fall" and decided I wanted to be a writer. I found two little orphaned hound dog pups on the side of the road and picked them up, named them Homer and Ann, and started taking care of them. I wrote a story, cribbing shamelessly from Harrison's novella, got it published, fell in love, and moved west, looking for

an empty place, a remote place, in which to work—rather, in which to write.

Elizabeth and I thought New Mexico might be remote enough, but didn't find what we were really looking for until we hit the Canadian line. We just kept drifting, and whether pulled by one thing or pushed by another, I'm still not sure. I know only that we were not in control. It was before this place got crowded. It was a long time ago.

I was talking about loss. I feel certain that sense of loss is one of the main reasons so many of our finest writers traffic in what is called, for better or worse, "nature writing." (I love the story I've heard told about the ethnobotanist and essayist Gary Paul Nabhan, who, evidently a little frustrated by such a sub-classification, once told an audience—or this is the story I've heard—"Look, there's only two kinds of writing: literature, and urban dysfunctional writing.")

There has always been a fabric of loss underlying, perhaps even composing, the movement, the passage, of any human culture through time. Way back even before Shakespeare or Tom McGuane, someone, somewhere, first said, "Nothing lasts forever." But I think no one would argue the fact that change and loss are occurring now at speeds that seem intolerable, and ever-accelerating. These changes and these losses are occurring not at organic speeds, or even in the rise-and-fall cycles of give-and-take—and not even at mechanical speeds—but at electronic speeds. There is the palpable sense, the awareness, that our

population numbers, and our consumption, is chewing away at something vital; that we're eating our world. Once again, the wolverine comes to mind— what James Dickey has called "the blind swallowing Thing."

There are all sorts of loss and injustice going on: with more people in the world, more than there's ever been. Nature writers and activists could be attaching themselves to issues other than the verities of air, water, food, shelter. We could be focusing on racial inequalities, gender inequalities, worker-employer inequalities. We could be protesting any of a hundred wars, or the poverty in our own country— one in five children in the United States being raised in poverty, with that number expected to double in our lifetime, while the stock market gallops to the moon, as if pulling our entrails out with it.

Are we lost children, writing instead about salamanders and ferns and mountain ranges of light and shadow, and about the profound movements our hearts undertake when we enter wild places?

I do not think so. I think we are moving in as close to the bedrock, as close to the bone of human existence, as is possible. All of the other loss comes or came—or is coming—from one source: the way we were shaped by landscape, and our relationships, through history, with the land and its other inhabitants.

There's not going to be a quick fix. Protecting the last roadless areas isn't going to help some poor child in New Jersey: not this year, and not in a hundred

years. You probably can't get there from here. Not even a glacier can get there from here.

But I do not like the direction our country, and the world, is going. Because of this, I need places—opportunities—where I know that when things get bad I can turn back around and head the other direction. Places of stillness, quiet, and sanctuary, where I can stand (not just in my mind, but in the graspable physical reality) and consider a great deepening stillness, while everywhere else around me is uproar, with the forest's trees bending and swaying.

Whether one agrees or disagrees with this country's and the world's direction, I think one would agree that we need opportunities—even if never utilized—to be able to cast back to the left at some point, even as we are presently casting right.

That in the application of that sinuous movement—rather than in the brittleness of a straight-line trajectory—true power is achieved, and a thing closer to freedom can be found.

I don't want to leave the wilderness behind. I don't want the very ground beneath us to be lost, nor the species that have helped shape us, and their stories—old forests, wolves, bears, owls.

I think that the more wild nature is lost, the more nature writers we're going to see. Perhaps there will some day be so many of them, as more wilderness is lost, that they will form beneath us their own kind of artificial fabric, in place of that lost wilderness. Perhaps the ground beneath us will be a fabric of the husks of their skeletons, crunchy, brittle, and crackly

underfoot, rather than the dark pungent rich vibrant living soil we can now still walk across. Perhaps in this manner—the casting down of so many husks—some fabric can be created that will hold us up a while longer and keep us from crashing through the abyss.

But what poor, thin substitute all our stories and tales will be then, for a memory that was once a reality.

There are two famous quotes by Thoreau, a hundred and fifty years ago, when there were about 250 thousand people living in this country, rather than 250 million. "I listen to [a] concert in which so many parts are wanting, . . ." Thoreau wrote in the spring of 1856.

> Many of those animal migrations and other phenomena by which the Indians marked the season are no longer to be observed. . . . I take infinite pains to know all the phenomena of the spring, for instance, thinking that I have here the entire poem, and then, to my chagrin, I hear that it is but an imperfect copy that I possess and have read, that my ancestors have torn out many of the first leaves and grandest passages, and mutilated it in many places. I should not like to think that some demigod had come before me and picked out some of the best of the stars. . . . I wish to know an entire heaven and an entire earth.

And, speaking further to loss:

> I long ago lost a hound, a bay horse, and a tur-
> tle dove, and am still on their trail. Many are
> the travellers I have spoken concerning them,
> describing their tracks and what calls they an-
> swered to. I have met one or two who had
> heard the hound, and the tramp of the horse,
> and even seen the dove disappear behind a
> cloud, and they seemed as anxious to recover
> them as if they had lost them themselves.

Cast left, cast right; I have a friend, the poet and
essayist Janisse Ray, who says that books, stories, are
as important as the stones and forests from which
they come: that books and stories saved her, as a girl.
And I think that Bill Kittredge would say the same
thing—that they helped save him as an adult.

But I also think that Janisse and Bill would tell
you that it was the woods *and* books—the sage of
Warner Valley of Oregon for Bill, and the Georgia
pines for Janisse—I can almost scent that sage, and
those pines, even now—almost—and that it was the
left and the right of these things that helped pull
them up. Two braids in the rope, not one. A strength-
ening. An antidote, a reaction, to loss.

What good can come from activism, then, in the face
of such testimony to the healing power of a walk in
the woods, or art? Everything in us tells us, either as
artists or woods-walkers, to recoil from the violence,
the bottomlessness, of activism. We are not afraid to
hurl ourselves into our joy of being in the woods, nor

are we afraid to hurl ourselves into our art in that manner, nor into love in that manner. Why do we understand innately, however, that such a hurling into activism will consume us? More importantly, what to do with that knowledge: how much art, how much life, to give over to it?

I believe the answer is, however much you think is appropriate. In proportion to what you perceive your blessings to be.

Activism gnaws at you, then fills the necessary vast empty or lonely spaces with clutter. You tend to lean your head down and push forward, the hunter, knowing what it is you want, and traveling—or trying to travel—in a straight line to get there. The opportunity to slash left and then right across that vast space is lost. That chance, that opportunity, vanishes, like a dream that cannot be remembered upon awakening.

And yet, if the activism itself can be viewed as a hard drift away from the thing it is you most want to be doing—the art—then perhaps it can be argued that the hard drift, in carrying you away from your art, might open up even more emptiness—the space, the prairie—unexploited on the other side. That the farther to one side you drift, the more space opens on the other side: so much so that it becomes like the stretching of taffy.

But how many stretchings—how much attenuation—can the creative process take? At what point does supple become brittle? It seems that no one ever recognizes the "proper" amount until the brittleness is already reached.

I miss my dog. I don't know how to prove it, but I feel fairly certain that such passions—hidden to the world, known only to the lover's heart—are safe antidote to that brittleness. Anchors.

In nature lies all patterns for sustainability. Most days I feel like the rhythms of activism versus those of art are like the volatile, cresting swells of predator-and-prey—a pursuit that is both tiring and tireless to both parties, unceasing and unavoidable: a fact of life. But perhaps this stretching-thin, this attenuation, can be found in the hibernations of bears and other creatures that sleep immersed in the earth for up to six months a year. What is their anchor between the dream, the spirit world, and the world above—the world of sunlight on the mountain beneath which they are sleeping?

Is their anchor a thing as nebulous as memory? Or perhaps the bond, the invisible wires that hold the two worlds together is the wilderness itself, or the essence of wildness. Perhaps if we lost all wildness, and all wilderness, the bears would one day not come out of hibernation. Surely all art would vanish, too.

The bears I have seen and watched, glimpsed, or occasionally studied for long moments or minutes—sometimes, rarely, for a full hour or two—have all seemed to possess such a dignity and grace, such an easiness and sureness to their movements, that it seems hard for me to believe there is any reluctance on their part that they must divide time between two worlds. If anything, it seems to me they are empowered by this ability to pass in and out of the

two lives, and that they may not be so much look-
ing for anchors to help them in their passages, but
that they might be the anchors themselves, for the
rest of us.

Of course there are few if any of us who can af-
ford or achieve that control over our lives: six months
of activism, then six months of art. Our world above,
and its rhythms, is too fragmented, and, in most
cases, too crowded. It's activism for a week or two,
then art for an hour. Many mornings I set the alarm
clock for 3 A.M., and work at fiction until just before
daylight. Then I will go back to sleep for an hour, try-
ing to use that little wedge of sleep as a kind of im-
permeable or at least semipermeable seal between the
two worlds, keeping them separate. I'll awaken again,
have breakfast, and begin the day of activism; and
which is the real world and which the shadow, some
days I cannot tell.

I do not think the creatures who live back in the
last roadless cores, the remaining wild places, know
such confusion, such brittleness.

I have no solution, no answer. I have only hope
that it can be done: pulling activism on a sled or
stoneboat behind you, while chasing art.

There is no choice. If you love a piece of country,
or an issue, and see that subject being harmed, you
have to act. Your unannounced love is almost surely
one-sided, unrequited, otherwise—but pipe-dream
thin, insubstantial.

And having made the commitment to activism—
in such amounts and energies as you can bear—then
comes the question of how to bear the frustration of

loss or, in some ways worse, the maddening attenuation of never knowing whether you're making a difference or not; of pushing ahead day after day, but always with no tangible signs of success.

Again, however, the answer is that there is no choice. On the blue-sky days when you feel hopeful about the immense task of not only helping to protect all last wild cores, but stitching them back together into some functional braid—and for good measure, helping to make the urban areas beyond those wild cores more livable as well—on those days of hope, you need nothing more to sustain you than the air you breathe.

On the more frequent days, the days in which you dare to fully evaluate our predicament—the raw force of numbers, the mass spillage of our population, and our ceaseless gnawing—you want to turn and run away; you want to run and hide.

But here the answer is simple as well. You have to engage with your beloved, even in the face of impending loss—especially in the face of that loss—as a means of showing honor and respect to the subject. As a means, a way, of not denying your love.

But wait a minute, the "pure" artist might say: isn't writing a beautiful poem, a heartbreaking story, or a great novel about the beloved subject the greatest and most lasting work of activism of all?

Perhaps it is a question of time, or the perceived lack of it. If a great poem or great novel is going to be written on behalf of a place, or an issue, it had better get written quick. What good does it do to labor for a quarter-century on a novel that galvanizes movement

against some social injustice that's a quarter of a century gone by?

It seems to me that it is like game birds getting up out of the thick cover and departing rapidly. If your intent is to gather birds, you've got to raise the gun and step up and fire, not write poems about how pretty they are.

A little thing that helps: people coming up to you in quiet moments, in the community—almost shyly, almost in secret—and commenting, from out of the blue, how much they appreciate the raucous, spirited, plaintive defense of what you love. It's not their desire, especially in this valley of hermits, to engage in that manner in the political wars of futility, but it is touching when they thank you for doing it. No one else will ever hear them thank you for it—they remain quiet, if not voiceless, back in the woods— and they know your activism is primarily on behalf of the needs of your own heart, but they come up occasionally anyway and say *thank you,* as if it is a thing, a favor, you have done for them, as well. These invisible wires of support help.

It's gravy, of course—unnecessary. For in the end, what pure love, what true love, requires external support? Obviously it must stand on its own to endure, to transcend mere affection, and reach the irreducible core.

Nonetheless, it helps. It's nice.

I'm a slow learner, and a slow thinker, too. Often realizations about events don't come to me until days

later. And too often, I think when I should just react, or react when instead I should pause and try to think. My timing seems off, in the world of man.

For instance, there is a certain look people in government agencies give activists, a look that it has taken me ten years to understand.

People who love the woods but are employed by the logging company, or the Forest Service, give you this look, this flicker in their eyes, when they tell you that they don't believe a certain proposed project—a clearcut, a dam, a mine—will have any long-term significant impact, because that is what they have to say to keep their job; but at the same time they are hoping you are fiercer and freer and will disagree with them, will fight with them—or with their agency, or their employer—and prevent them from carrying out that harm.

It took me a long time to understand what was going on when their words said one thing but their eyes said another.

I believe a fine credo for the activist can be found in a passage not from Thomas Merton but from Osborne Russell, a trapper in the 1830s, who was not describing any sort of activism, but merely journeying through the West during a physically demanding time. The metaphor, however, speaks to the emotional ass-kicking the activist encounters, in his or her own long journeys.

Tired of writing letters and licking stamps? Read a page from the trapper's journal:

> . . . laid down to shake tremble and suffer with the cold till day light when we started and

travelled as fast as our wearied limbs would permit in the same direction we had travelled the day before descending a gradual slope towards the head of powder river until near night when finding some water standing in a puddle with large quantities of dry sage about it we killed a Bull near by taking his skin for a bed and some of the best meat for supper passed the night very comfortable. We were now in sight of the red Butes on the river Platte— which appeared about 40 ms distant SE The next morning we found the weather foggy with sleet and snow falling I tried to persuade my comrades to stop until it should clear away urging the probability of our steering a wrong course as we could not see more than 200 paces but they concluded we could travel by the wind and after making several objections to travelling by Such an uncertain guide to no purpose I gave up the argument and we started and travelled about ESE for 3 hours as we supposed then stopped a short time and built a fire of Sage while it still continued to snow and rain alternately. and seeing no signs of the weather clearing we started again and went on till near Night when the Sun coming out we found that instead of travelling ESE our course had been NNE and we were as far from the Platte as we were in the Morning with the Country around us very broken intersected with deep ravines and gullies We saw some Bulls 3 or 4 Mls ahead and Started for them After the Sun hat set it clouded up and began

to rain. We reached the Bulls about an hour after dark Allen crawled close to them shot and killed one took off the skin and some of the meat whilst myself and the others were groping around in the dark hunting a few bits of Sage and weeds to make a fire and after repeated unsuccessful exertions we at last kindled a blaze. We had plenty of water under over and all around us but could not find a stick for fuel bigger than a mans thumb. We sat down round the fire with each holding a piece of beef over it on a stick with one hand while the other was employed in keeping up the blaze by feeding it with wet sage and weeds until the meat was warmed thro. when it was devoured with an observation that "Bull Meat was dry eating when cooked too much." After supper (if I may be allowed to disgrace the term by applying it to such a Wolfish feast) we spread the Bull skin down in the mud in the dryest place we could find and laid down upon it. Our fire was immediately put out by the rain and all was Egyptian darkness. We lay tolerably comfortable whilst the skin retained its animal warmth and remained above the surface but the mud being soft the weight of our bodies sunk it by degrees below the water level which ran under us on the skin but we concluded it was best to lie still and keep the water warm that was about us for if we stirred we let in the cold water and if we removed our bed we were more likely to find a worse instead of a better

place as it rained very hard all night. At daylight we arose bid adieu to our uncomfortable lodgins and left as fast as our legs would carry us thro. the mud and water and after travelling about 12 Mls South course we stopped killed a bull and took breakfast. After eating we travelled south until sunset.

Activism is love casting left while despair wants to cast right. The hunter plunging straight ahead into this turmoil of wind, these secret shifts of scent emanating from the one true and real object—sometimes fixed and hidden, other times sneaking away.

Activism has never protected permanently—for all time, for everyone's children who will ever be born—a single acre of the public wildlands in the Yaak. Year after year, we face instead the maddening, frustrating, eroding struggle to postpone and delay, defer, minimize, and mitigate the timber harvests planned in these last raw wild dark shady cores of health. The roads spiral around and around the mountains, up and down the canyons, and across the creeks, until there are only little islands left: an archipelago of wildness, rather than an entire continent.

The government publications addressing proposed timber harvests on the federal lands state that they attempt to consider the "purpose and need" for each action, but clearly, Americans have not yet—despite the eloquent writings of every nature writer since the time of Thoreau—raised the level of the dialogue

to the point where it is a given in our culture that we have a purpose and a need for plain raw wilderness. That wilderness is a use in itself: if indeed everything, *everything,* in our sphere must be judged by its most unimaginative utility.

I think this brings us back to the notion of art versus activism. Who could be more artful or eloquent, more intelligent or impassioned in writing about issues than Thoreau, a hundred and thirty years ago, or Muir, seventy-five years ago, or Leopold, sixty years ago, or Stegner or Abbey, as recently as yesterday's shadow? Art is required to save wild places, more than ever—to help new shapes, or incorporate them into a culture—but that kind of change takes generations.

You've got to step in and do both. The vanishing wilderness might be able to tolerate a few slackers who traffic, who indulge, in nothing but pure art—just as the wilderness tolerates, even requires, every diversity, in its radiant health—but it's my feeling that if you choose to put yourself in that rarefied company of the artists whose higher callings lie beyond the realm of the muck and sweat of activism, then you'd better be damned good. I mean, you'd better deliver the goods, if you love a thing but choose to take the long path away from it.

We have not yet protected a single acre of permanent wilderness in the Yaak. Where, then, does this energy, that effort, go? Perhaps it is mule-headed, linear-Cartesian foolishness, but I still believe that, even in

the invisibility of neither succeeding nor failing, some days we are moving closer to succeeding: like tossing stones into the bottom of a vast lake, in the hopes of someday building a little stone footbridge to span it.

Here's what's going on in the Yaak. We've formed the little group, the Yaak Valley Forest Council, to speak with a more unified voice.

There is a national letter-writing campaign.

There is, of course, a web page, with biweekly updates. Its address:

www.geocities.com/RainForest/Vines/5054

We've had four documentary crews film specials about the Yaak. They've got over a hundred hours of tape; we're awaiting, searching for, dollars to begin the editing of an activist video to distribute to Congress and the administration.

One of the film crews is also seeking, in conjunction with the Orion Society, to produce an hour-long program for public television. In the spring of 1997, the Orion Society brought nature writers from all around the country to give a week of public readings and discussions on behalf of the Yaak's roadless lands. The community was thus exposed to some of the people whose writings may help in some way shape public policy for the federal lands around which they live—the lands that supply these communities with their spiritual as well as physical life. And the writers—Terry Tempest Williams, Richard

Nelson, Robert Michael Pyle, and Janisse Ray—were exposed to the human communities that lived next to and within these lands and issues about which those writers are writing.

And certainly in the exchange, it showed the community up here—many of whom had never met or even seen a hard-core environmental activist—that they were not all the devil-beasts they'd been led to believe but were instead compassionate, entertaining, intelligent, real people. And vice versa.

We hope to continue the tradition and bring in more writers, to give more readings, every year. In 1998, Bill McKibben, Sue Halpern, Bill Kittredge, and Annick Smith came and gave readings. This year, the poet Sandra Alcosser and the journalist Richard Manning will give readings.

The nearest conservation organization, the Cabinet Resources Group, is holding frequent informal dialogues with the supervisor of the Kootenai National Forest, to keep him appraised—relentlessly—of our "purpose and need" (in the lingo of government documents). Disagreements in these meetings are not uncommon, but we are grateful to have the opportunity to sit down and talk.

Another group has formed down in Libby, the Kootenai Forest Congress, which is an informal assemblage of loggers, environmentalists, and general community members somewhere in between. In our monthly meetings, we discuss forest issues and try to

reach consensus on those issues in order to provide input for the Forest Service.

The hours spent on art—fiction, say, or poetry, or creative nonfiction—or the hours spent reading great literature, or even the labor-intensive loving craft of time spent on careful editing, are whittled down by each meeting, each phone call, each letter, each drive to town; each twist and clench of the furious and frantic heart. You feel within you the whittling away, the diminishment of the rich excess, the bounty of time and space, in which you most desire to work.

It might be true that whittling down can sometimes produce, for a while, a sharper edge—but when you are the thing, the blade, being whittled, it is nervous making after a while, as you feel the steel, or whatever essence is within, becoming thinner and thinner; as you begin to be aware, for the first time, of the notion or possibility of a brittleness somewhere within.

I keep thinking about that Merton quote: the one about how too much activism can lead to a violence of the soul—a destruction of the inner peace that can otherwise make art, or a life lived, fruitful.

But so too does the loss, the vanishing, of the wilderness lead to these things.

The valley was fortunate for a couple of summers to have the Round River Conservation Studies program active in the Yaak. Five or six students spend the

summer camped in the Yaak studying field ecology, silviculture, literature, and natural history, and receive seventeen hours of college credit. Exams are rigorous, and at the end of the semester the students produce a term paper. The first year's report was a qualitative analysis of the Yaak's grizzly bear habitat, and a comparison of that habitat to the San Juan mountain range in southern Colorado. The second year's paper was a report on the social and biological values of the last roadless cores in the Yaak.

The program ran twelve thousand dollars in the hole last summer. Was it worth it? It's hard to say. All the stones add up. After so many years of silence—save for the rumblings of hundreds of thousands of logging trucks leaving the valley, leaving the county, leaving the state—I do not think the twelve thousand was a waste, or a loss. The cost of only three of those truckloads of raw logs. I continue to think we have room in the Yaak for two things, rather than simply one.

This year, Project Lighthawk—"the Environmental Air Force"—provided free flights over the valley to residents interested in viewing the fragmentation, the quiltwork of clearcuts, from the sky. There were numerous passengers.

On behalf of its students as well as valley residents, Round River brought in the Canadian foresters and ecologists Herb and Susan Hammond to give a free three-day workshop on how to help us convert our forests to a sustainable, value-added extractive process that still relies on logging: preserving, rather

than losing, that vanishing culture. One person showed up in Libby, the mill town; the meeting room in the Yaak was only half-filled.

I, and other members of the Yaak Valley Forest Council, believe that sustainable forestry is possible in the Yaak. After so many years of watching the big trees hauled out, we see the need in many places now for the thinning of the small-diameter trees that have rushed in to take the place of the great giants. We're working hard to help make more small sales available, rather than just a few massive ones, as is currently the case. More numerous, smaller sales (often utilizing smaller diameter trees) would help give loggers who live in the valley a better chance of getting these bids. And although there are many variables, such as the expertise and motivation of the logger, the smaller sales generally impact the forest less than the larger sales. If properly planned, administered, and executed, these cuts can even be of benefit to certain species of wildlife and have other values.

And if the cuts are of benefit, the loggers, or other workers operating in the unit, should be compensated for that. The logger should be motivated by the end result of the job—by the forest-community values retained or created, according to the desires of the local community, in conjunction with the laws of the land and the larger public—rather than by the current accounting system that assigns value merely to volume, and that equates a logger's pay not with expertise but simply raw volume.

Montana conservationist Steve Thompson would like to cleave the payment of the loggers (or other contractors, such as road builders, road obliterators, tree planters, etc.) from the pile of logs, the deck, that is produced from each project. The logger and other contractors, in Thompson's plan, would simply do their work, receive their pay checks, and then leave.

At that point, outside bidders would then come in, look at what was produced, and make their bids. The possibility of greed and corruption—the *incentive* for cutting for volume—would vanish. Too many loggers speak of having to "turn their brains off" when they go into a Forest Service sale, knowing that they are chasing volume and must cut each marked tree— or rather, cut every tree that does not have a bright blue slash painted on it. Thompson's (and others') system, however, would allow loggers more flexibility. Loggers could choose the diseased trees and leave the healthy ones. According to what the community desired, they could leave clumps or islands of diversity. They could even leave logs behind on the ground, where needed, to rot and provide soil nutrients, or to buffer against erosion. They could work with their minds and their bodies, as if in a garden rather than having to go on autopilot. Then there would be no need for new roads.

The program would pay for itself, economists believe, through savings in the tree-marking process, as well as through not having to pay 25 percent of gross receipts to the county in which the timber is cut, as is currently the case (a payment method that, too often,

provides another incentive for abuse). The counties would be repaid from other funds in the treasury, and from the increase in available taxes on salaries paid to the local workers.

The Forest Service could keep any dollars left from the timber sales to continue funding this program, rather than continuing to be puppeteered by Congress. The Forest Service would then be motivated to seek out the highest bidders, to find the highest value, for that wood—searching for, and helping in that manner to develop, the value-added industries we need to be creating, rather than trying to match the Canadians and other countries tree for tree. In the 1999 appropriations bill, Congress authorized nine pilot projects that would operate under this model in Montana and Idaho (as well as nineteen other projects elsewhere across the country). The Yaak Valley Forest Council has lobbied hard to have one of these projects awarded to the valley.

The Pew Charitable Trust recently funded a documentary project that will photograph and take the oral histories of twelve grassroots organizations around the country that are working to better their community, as examples of democracy, and the Yaak Valley Forest Council was selected as one of these groups. The exhibit will be collected into a book and placed on permanent exhibit at the University of Arizona's art collection.

Can literature help protect a place? Can some reciprocity exist between the real, fixed anchor of a wild

place, and the intangible values—chief among them, the art—produced from that source? Can the art give back to the land some of that invisible energy that the land bequeathed to the art, or is that as impossible an act, a goal, as capturing wind, sun, stardust? We intend to find out.

We've been writing grants to compile an anthology of writings about the Yaak by county residents both in and outside of the valley. A written testimony of what the place means to them, and has meant to their families over time, as a way of gaining, we hope, a broader perspective, and illustrating that the Yaak is and always has been far more than just a place to tote raw logs out of.

We aim to bring in more writers to conduct writing workshops, and then compile and publish (and market) that anthology, both as a tool for gathering and focusing community pride, as well as a means of lobbying for our goal of keeping those last roadless areas roadless. We'll present the book to the various politicians and agency personnel whose decisions influence the future viability of this wild place.

I'd like to see a fine-arts press making some of its paper from Yaak trees, Yaak fiber. This forest has so much to give in spirit, beyond merely the brute, limited dimensions of raw timber on the backs of trucks headed down the hill.

It whittles you down. You know in your heart, or in your blood, to range far and wide, as an artist—to stay on the outside, to avoid being stereotyped or

labeled, just as you endeavor, sometimes unsuccessfully to avoid labeling or stereotyping others; to keep things fresh and vital. And yet in that frantic violence of activism, I can rarely view anything these days save through the monocle of the Yaak. It is like pulling a plow when instead you want to be ice skating. No writer, no artist, wants to be Johnny One-Note.

But for the Yaak I would gladly be Johnny Zero-Note. I would trade any book for one hundred seventy-five thousand acres of wilderness. One hundred and seventy-five thousand acres protected for five hundred years equals 875 million acre-years. Warblers, elk music, starlight on the fur of sleeping wolves, wild trout—I would trade a book for that.

In ten years I've published about fifty magazine and newspaper articles arguing for wilderness protection for those last roadless cores in the Yaak, to a cumulative readership of over 50 million people. And still, not one stone, not one gram of soil, is protected.

I think we are only starting. Most days I think it might easily take another fifty years, or even a hundred, to protect those last cores. But that's certainly no reason to back off, or turn away. We just have to hope others come along behind us who love the place as much as we do.

If it sounds like I'm trolling for dollars here, it's probably because I am. What I'm trolling—or casting—for is really only the protection of those last little roadless cores, but most of the ideas we have require money,

which we don't have. We don't aim to pour the money down the rat hole, the gaping pig's-jaw gulp of politicians-for-hire, the way the opposition does (though perhaps we should), but rather into art, and into activism.

This decision may be fatal and old-fashioned, but it is the one we have made. It's frankly maddening, borderline humiliating, to be asking for dollars—even from grantmaking organizations whose job it is to provide and distribute those dollars—soliciting from hired-and-paid executors the necessary grants to help fund your volunteers. But again, love has no pride; anything, or almost anything, for the cause. Anything within the limits of the heart's honesty.

The way the activist lines up his or her heart against the machines, and against the destruction of mystery and respect: it is as brutal and confusing a conflict as if the earth were to one day do battle and rage against the sky. The Wise-Use groups are funded by the unending legions of international snowmobile makers, international oil and gas companies, multi-national timber companies, foreign mining limited partnerships, and so forth. They own their puppet politicians, and they can outspend us a thousand-to-one in their gluttonous frenzy to battle for this country's last wild crumbs.

Earth and sky: how does love stand up against the brute power of money?

No less a hypercapitalist publication than the *Wall Street Journal* has reported on the unacknowledged annual savings—trillions of dollars a year—to

be gotten from a healthy, fully functioning ecosystem, rather than a stagnant one. Wilderness cores provide for the filtration of clean air and water both above and below the ground; for the transfer of nutrients, the absorption of carbon dioxide, the production of oxygen.

No machine, at any cost, could do this with any fraction of the efficiency that now exists, though that efficiency is fast fading.

At what point did the cleaving, the rift, occur, that separated—if only in our minds, and only for the moment—the relationship between the words *economics* and *ecosystem?* How could language fail us so?

Consider the wilderness. Crawl on your hands and knees into even one of the smaller ones—say, a four- or five-thousand acre wilderness, someplace else, not here—and examine the mosaic of each plant, tiny at first, and then increasingly larger. Examine them daily then for every day of the year, and annually, for some small wedge of time—forty or fifty years.

What man or woman thinks he or she could recreate or build such a garden?

Dollars, machine parts, spirit: what a confusing, neurotic time it is to be an activist. But so crowded are the events of the human world these days that I could no more live solely within "pure" art than I could return to "pure" childhood. I need wilderness. The wilderness is vanishing. It would be wrong, unnatural, for me not to act on my needs.

It would be wrong, too, to lay low and expect or hope that another would act on my behalf. It would be wrong for me to not join in with an energy commensurate and proportional to my need, my desire.

We will see where it all lands: whether our love for wild country will be stronger than, and outcompete, others' love for money-in-the-fist now.

Supply and demand. Finite resources in a fixed, limited system. Both "sides" understand this. Both "sides" will be saved together or will go down together.

This world could not have been created in order for the spirit to be subsumed by money.

This world, and life itself, is nothing but an amazing receptacle for spirit. It is not a receptacle for money, nor are our bodies, nor our minds.

4 ART

I want to say a little more about my dog who went away: the best pointer anyone will ever see. When he ran he did so unceasingly, and then when he went on point, it was so staunch, so sudden, that it was like a tomahawk being buried in a piece of wood, with that kind of an echo of stillness-in-the-world. With the exception of my daughters coming out of their mother—each early on a spring morning—it was the most beautiful thing I'd ever seen.

What I want to convey about Colter is how *irreducible* he was. And still is. With the training of most dogs, what is involved is a building-up, an accretion of talent, a stretching of resources—a reaching toward some desired level of performance.

From the very start with Colter, what was involved, however—what was clearly required—was a whittling down; a chiseling down, a carving and sculpting from the mountain of fire and joy and bird-lust that was his heart.

He was so unlike anything I had ever seen or known, much less had contact with. I favor the incremental, the geological; the steady, muscular, forward earnest trudge—and here I was suddenly "in possession" of a bolt of lightning. Feeding him in the mornings and evenings; training him, hunting him, walking with him. Being responsible for him.

The first time he was turned loose into the woods, at dusk, in the Yaak, he ran twenty yards in less than two seconds, picked up ground scent,

wheeled, ran to it with his head held high, stopped, and pointed; and when the bird flushed and flew, it was so close to dusk that when I shot, flame leapt from the barrel. I hit the bird, and Colter ran forward and picked the bird up and brought it over to me and dropped it in my hand: a dark red-brown grouse, a dark dog in dark woods nearing night. Certainly I would never again be the same, stepping forward into joy, a specific joy, as if onto a long voyage. . . .

The first time my friend Tim and I took him hunting but left him in the back of the truck, in the camper shell portion of the truck (in order to hunt Tim's great golden retriever, Maddie, by herself for one run), we had not traveled far into the woods (listening to the echoes of Colter's plaintive wails and howls, his *desolation* at being kept from the thing he loved, the thing that *was* him; there was no separation) before we heard a thunderous trammeling of the brush behind us.

We whirled and saw a brown blur rocketing toward us, and for long micromoments believed it was a bear, until we understood—as he roared past us, hunting—that it was Colter. I believed at first that his desire alone had been enough to shape-shift him from the inside to the outside—but upon returning to the truck we found where he had gnawed his way through the plastic window and fiberglass of the camper top.

He was not like me. He was not cautious. I needed him.

When he ran through the woods up here, especially in late October, when the leaves were off the snowberry bushes but the branches were still laden with the ripe white little berries, they would pop loose from the branches in his wake as he plowed through them, so that there would be berries flying upward in all directions, like an inverse kind of rain—a force of nature ripping through those dry bushes—snowberries then falling like pearls pattering on the leaves of the forest floor.

When we got a grouse, and I plucked and cleaned it, I would examine the crop to see what it had been eating. Often the crop would be gorged with those snowberries, every bit as beautiful as pearls.

Other times there would be fresh green bits of clover and the crimson little globes of kinnickinnick berries, which reminded me of Christmas coming; the two colors, red and green.

My friends Tom and Nancy sometimes hang the little crops of grouse, with these two colors bright in them, from their Christmas trees, celebrating nothing less than life and death and renewal, with beauty thrown in for good measure.

For a while I hunted Colter with a bell hung from his collar, so that I could tell where he was as he raced through the woods, but it was no use; he seemed to travel faster than the speed of sound, so that the furious jingling was everywhere—as if attached to the front of a roller coaster. I would hear the jangling

music behind me and turn to look, but I'd be too late; now he would be fifty yards on the other side of me. I gave up on that furious music and tried to follow him, the beautiful sight of him, with only my eyes.

The genius dog trainer down in Texas, Jarrett Thompson, spent all his time trying simply to rein Colter in—showing him the boundaries we wanted him to stay within. And what generous boundaries they were, given Colter's speed and power and nose, and the amount of country he could cover with those long legs, that gallop; and then, from that physical ground covered, a hundredfold farther, evaluating the country ahead by its invisible rivers of scent. . . .

We carved and whittled at him. Taught him what *not* to do. All that remained in the end was the pure essence of what was left of him. That fire, retained and bounded, if not controlled, to a zone useful to a shotgunner. It was a little like trying to fit a volcano into two cupped hands.

What was left, after four years of training, was perfection.

And now there is only memory. I have hung the bones, the carcasses, of some of the birds we hunted together, on a string, like an amulet, against the side of my writing cabin: birds he found and pointed, birds he led me to, and which I shot, and which he retrieved or pointed to again, and which I carried home then and cleaned and plucked and ate, turning them from seemingly irreducible flights of feathered beauty flying fast through the forest instead into my

own flesh and blood and bone. It is a metamorphosis I do not take lightly.

I do not mean to imply—could never dream or hope—that any conversion of flesh could be judged worthy: bird to artist, bird to human muscle. On the surface, and perhaps even at depth, the equation, the formula of conversion, falters: the interruption of beauty. I mean only to say that I am a hunter.

I'm not sure that I have much to say about art. When asked for my advice or thoughts on the matter, I find myself unable to travel much further than the kindergarten advice of, "Show, don't tell." I would rather someone lead me through the woods and stop at a beautiful rock outcrop they wanted me to see, than to have them tell me, *"It is beautiful."* I would like to touch it myself, rather than have them tell me what it feels like.

I like the notion espoused by John Gardner, and others, that there are only two stories in the world: either a man or a woman goes on a journey, or a stranger rides into town. But that out of only those two possibilities, or some combination of both, comes—as with life itself—infinite variability.

I like the notion that in a good story, the germ of the story—what the story is about—can be found in the first sentence, or the first paragraph, or, at the very latest, somewhere on the first page.

I love what Annie Dillard has written:

One of the few things I know about writing is this: spend it all, shoot it, play it, lose it, all, right away, every time. Do not hoard what seems good for a later place in the book, or for another book; give it, give it all, give it now. The impulse to save something good for a better place later is the signal to spend it now. Something more will arise for later, something better. These things fill from behind, from beneath, like well water. Similarly, the impulse to keep to yourself what you have learned is not only shameful, it is destructive. Anything you do not give freely and abundantly becomes lost to you. You open your safe and find ashes.

After Michelangelo died, someone found in his studio a piece of paper on which he had written a note to his apprentice, in the handwriting of his old age: "Draw, Antonio, draw, Antonio, draw and do not waste time."

I like what Kafka said, about how a book should be "the ax for the frozen sea inside us."

I'm so slow-ahead and old fashioned and orthodox that I like a story to have a beginning, a middle, and an end—and I like what Flaubert said, about living a life that is mild and regular, in order that you may be violently original and daring in your art.

Left creates right; chaos and fragmentation create a need, a yearning, for logic, order, and design.

Out of this sinuosity, this casting left before veering right, comes once again that rhythm of sinuosity—a forward momentum, a narrative, a story being

created from nothing more than the movement of desire itself. It is the creation of a thing almost like life itself being formed from the raw materials of dust, clay, rain, potassium, hydrogen, carbon.

So much advice about the writing life is so simple. The technique, the style and voice and word choice and sentence crafting and event structuring, or event unfolding, is the easy part.

Stepping away from the world—stepping fully away from the world, unmoored, yet with confidence and courage, enthusiasm—falling, or soaring, but either way, leaving the world—that is the hard part.

Two good pieces of advice from Hemingway:

> The best way [to write] is always to stop when you are going good and when you know what will happen next. If you do that every day when you are writing a novel you will never be stuck.

And:

> The most essential gift for a good writer is a built-in, shockproof, shit detector. This is the writer's radar and all great writers have had it.

We've all heard these. There are probably no more than ten essential "rules" for writing. Beyond that, it is all about how far you can leap, how far you can fly—how far you can fall and still come back.

Colter had a shockproof built-in shit detector. Sometimes when he would go on point, crouched like a cat, one paw raised elegantly, his nose and the

tip of his tail would twitch, indicating that he was pointing to a place where the bird had just been, perhaps only seconds ago, pointing the blurred outline of scent, of where it had just been—scent in the shadowy shape of a bird, scent slowly dissolving from the shape of a bird—though other times he would not quite be sure. But when he stopped blinking, and when that little nub of a tail, that little metronome, stopped, you could take it to the bank that that bird was there.

I can't begin to count how many times I would be hunting with someone who, when Colter pointed with locked tail, and the bird refused to flush, then that person—not knowing Colter—would then refuse to believe the bird was there. Sometimes I would have to unload my gun and set it down and get on my hands and knees and burrow through the grass in front of Colter's nose, finally prompting the bird to erupt from its previous place of invisibility, rising as if from some magician's trick. He was maybe the only perfect thing I've ever known in the world. It's easy some days to believe that he might be gone from it already, so soon. What's hard to believe is that I got to hunt with him for four years.

I think it's good for a writer, or an artist, to stay on the outside of things as much as possible. I also think this is a talent or characteristic—this ability to get outside—that artists are born with, or for which they have a predisposition, which can then be sharpened more acutely by the passage of the artist through life.

Hence this outsiderness is more likely a talent or ability that can be lost rather than built up and developed. Perhaps I am wrong but it seems to me that as a child and then a teenager and then a young man, I had no problem feeling slightly outside the world—slightly ecstatic at being so—and that it is that wildness, that drifty freedom, that strange combination of possibility and certainty, which I seek to return to in the telling of stories. The deeper woods. It seems to me to be a thing I have always had, or once had, and need only—on good days—work at holding onto it, rather than building it up anew, or rediscovering, or recreating, that younger sense of the world.

Jim Harrison writes:

> Who is the other,
> this secret sharer
> who directs the hand
> that twists the heart,
> the voice calling out to me
> between feather and stone
> the hour before dawn?

I think an artist's outsiderness is to a large degree innate, and that the world then whittles away, or can whittle away, reducing you further toward that essence. Your earliest inclinations have probably almost always been to stay outside—to turn away, if only to set up, in so doing, some greater distance across which yearning and other passions can travel. A larger field.

You sit in the back of the classroom. You do not

raise your hand, but listen. You watch for a long time before participating.

Such tameness creates the need for recklessness. Such stasis creates the need for motion. A narrative emerges.

You dream of shouting, but no words come out. You wake up in the morning and pick up your pen.

I remember my first writer's conference. I had quit my job as a geologist in the city, in Mississippi, and was living thirty miles outside of town in a leaning little farmhouse. I kept an old wooden table set up out in the middle of a grassy field, and in the mornings, I would fix a little thermos of coffee and then walk out there barefooted and shirtless, wearing only shorts—the dew wet upon my feet and around my ankles—and I would sit down at that table out in the middle of the green field, unseen by anyone except God above and my two hounds up on the porch, Homer and Ann, and I would write.

The sun would grow brighter and the day would begin to warm, until I was sweating and locusts were calling back in the woods. After the coffee ran out I would drink iced tea, and then water, and keep writing. Then I would finally stop and go for a run or a ride with the dogs, then come back home and shower and work on a geological map in the cool shade of the living room. Then I'd lie on the bed and read, and nap, and around dusk would drive over to Vicksburg to meet Elizabeth for supper. Huge stretches of time would pass in which I saw no one else, spoke to no one else.

When we decided to load up the truck and drive out to a writer's conference, we picked one in the West, so that we could see the mountains again. We put our backpacks in the back of the truck—covered them with plastic trash bags to keep them dry against summer storms—and chained the beautiful hounds in the back to keep them from leaping out, and on bald old tires and a sagging suspension, we drove north and west, north and west, leaving another leaving, taking as almost ever yet one more step outside. The hounds stood on top of the truck's cab with their ears flapping and grinned into the wind.

The conference was being held high in the mountains in Utah, in a resort town. Participants were expected to stay in the big hotel. We were absolutely broke—spending our last dollars on gas, and the conference—and so we camped along the way and, once we got there, camped about an hour away from the conference, higher in the mountains. We arose early each cold morning and fixed breakfast, then drove back down toward the resort. There was a shower in the changing room next to the pool, of which we would avail ourselves; it was impossible, with so many hundreds of guests moving about, for the hotel staff to tell who was registered and who was not.

We came in as if wolves from some dark plains, and filtered into the hotel throughout the day. Elizabeth swam in that pool and lay out and read and went for walks and to art galleries in town while I went to the classes. We kept the hounds chained in the shade beneath a big tree on one of the green

lawns. We helped ourselves to the coffee and donuts, the wine and cheese, and went to the readings in the evenings, and then drove back "home" beneath the bright stars, where we would make another campfire. Thirty, forty miles outside of town felt just right. We could go in, but we could leave, too.

I remember one cold morning—there had been a frost—when on the way to the hotel we passed by a dead, car-struck porcupine lying mounded in the road.

I pulled over to get out and examine it at close range, never having been in such proximity to one.

I was out on the road plucking quills from it, to send to my family back in Texas, when my instructor drove past. He stopped and looked at me but said nothing, then drove away—believing, I think, that I intended to eat that porcupine.

For a while, when I was living and working in Mississippi, I desired to be Eudora Welty's yard boy. I was convinced that she went different places in the world beneath or beyond this one, and breathed different air. I bought a lawn mower and, to avoid seeming as if I was targeting her, put up flyers all throughout her neighborhood advertising my services at cut-rate discounts, to ensure that I got plenty of work. I did not hear from her, but received enthusiastic responses from most of her neighbors, so that every day on my lunch break I would change from my suit and tie into grubby old yard clothes and would go cut the yards of strangers almost for free

under the hot Mississippi sun. I prowled the perimeters of those lawns like an uncaged lion or tiger, hoping to catch her scent, hoping to learn and see how and why she was different. Sometimes from a distance I would see her drive up and get out of her car and go into her little house. She looked like a goddess, walked like a goddess.

Hero worship: After Elizabeth and I moved to Montana, we received one morning on the twelve-volt radio phone a crackly, staticky transmission from Jim Harrison, with whom I'd corresponded a little, but had never met.

Jim was in the neighborhood, he said, visiting his daughter and son-in-law, and asked if we'd like to come over for dinner that evening. He said to meet him at the painter Russell Chatham's cabin—that he'd cook barbecue in honor of our Southernness.

It was a long, complex miscommunication, but the gist of it was that Jim had confused where I used to live—Terry, Mississippi—with where we were now—Troy, Montana—as being instead Terry, Montana, which is close to where he was going to be visiting, though a long damn way from Troy, Montana. But we didn't tell him any of that; an invitation was an invitation. We grabbed our sleeping bags, chained the dogs once again in back, and hurtled the five hundred miles south toward where dinner would be held that evening.

We arrived at dusk. I could see the friends and family of my mentor visiting out in the meadow. I

unhitched my pups to give their legs a stretch after the long hard ride.

Like twin devils they leapt immediately from the truck and began coursing straight for the scent they had been breathing since their arrival: a scent made luscious, I suppose, by the summer day's cooling currents. A house cat was out there perched on an immense boulder, a fieldstone. Not just any cat, either, but a New York City cat, belonging to Jim's daughter, Jamie, and to her husband, Steve. An old beloved blind cat who had been with Jamie since she was a child: seventeen years old, gimpy, blind as a sage, and now awaiting its final moments as the two twin hounds of black-and-tan terror bore down on Lulu like devils hurled from hell.

But the old blind cat had not gotten to be ancient through any lack of luck or cunning in the world, and despite being in new surroundings, she leapt into the deep grass like a panther, just as the dogs reached and scoured the top of her boulder. For a moment it looked as if she had been consumed, but then we saw the tall green grass furrowing wildly in zig-zagging fashion, as if a bolt of lightning were passing through it, and right behind that shaking grass followed the larger furrow of my two hounds shadowing her every move and accelerating, with the two furrows, cat and dogs, narrowing imminently and quickly toward fusion.

I was running after them, yelling, trying to call them back—it was like shouting at stones, or the rain—and Jamie was chasing them too, crying and cursing.

They caught Lulu at one point—tufts of fur floated upward like feathers; both dogs and cat gave a yowl—but evidently Lulu still had a few claws or teeth left hidden somewhere, and the chase was on again.

Perhaps in the clarity of her terror, Lulu's sight was restored to her, even if only briefly. Now she rushed for the sanctuary of a rusting, abandoned Model-T at the bottom of the hill, the old car sinking into that sea of grass, and she scooted beneath it just as Homer and Ann, overshooting their mark, collided twosquare with it, banging their bodies into it like the foils in some Saturday morning cartoon.

They recovered, and were working either side of the old vehicle, digging furiously. They had forced her to take refuge in a gopher burrow, crawling down into the dusty innards and chambers of the earth. Plumes of gray smoke rose into the air as the dogs pursued her, digging wildly—it looked as if the old car had come back to life, and was trying to start— but finally Jamie was able to grab one dog, and I the other, and I hurried them back to the truck while Jamie crawled under the car and tried to gather her spitting, snarling cat.

By the time I got to the top of the hill, my mentor came out, big as a bear and wearing an apron and holding a glass of wine. His hands and apron were stained with barbecue sauce, and he squinted down the hill into that dim light, curious about all the uproar.

I introduced myself to him. I expected him to say something profound or at least writerly upon our first meeting. Instead, he gestured toward the hot

sauce on his apron and cautioned, "Don't touch your pecker now."

I do not think you can help but remain somewhat outside of the world, if you are an artist. Perhaps this is one of the things that makes the beauty of the physical world; the so-called natural world, so appealing to so many writers and other artists. That, and nature's model for art: a great and complex order, assembled—woven, sculpted, written, shaped—out of chaos and disorder, disintegration.

It's instinctive, I think, this otherness, this alienation, at times, toward the world of fellow men and women. In this distance, however, (and again, no matter whether yearning to close that distance, or celebrating that separation), I believe a space exists in which art can be crafted. It seems efficient to focus, if one can, on not losing that space in one's mind. To focus on holding onto it—that wildness—rather than losing or abandoning it, then trying to resummon or recreate it. Or never knowing it, never remembering it, in the first place.

An argument, it would seem, against art, and for activism:

Why fool with the invisible threads—mists of scent, skeins of words, moods, make-believe stories, sing-song poems—when you can bend down and cup your hand, the flesh and bone and warmth of it, against the great curve of the earth?

I guess it's fairly well established by now that I'm pretty much a neurotic on the subject.

Harrison, as ever, is lucid. In *Just Before Dark*, he invokes Wallace Stevens: "The worst of all things is not to live in a physical world."

Harrison writes, in his introduction,

> It had occurred to me early, by the mid-sixties in fact, that I was temperamentally unsuited for teaching, the usual career of a literary writer. I hadn't thought it through at the time but the real reason for the brevity of my teaching career was that the universities I admired were so far from the woods and water I had emotionally depended on since my youth. To earn a living for my family I began an essentially quadra-schizoid existence, continuing to write the poems I had begun with and adding all matter of journalism, novels, and screenplays.
>
> When a writer lifts his obsessed and frazzled head from the work there is frequently what Walker Percy called "the reentry problem." Literary history abounds with cases of multi-addiction and personal mayhem of the most childish sort. To put it modestly, I have not been consistently innovative in avoiding the usual problems, but have tried to counter them with equal obsessions for the natural world, fishing, hunting, the study of Native Americans, cooking, the practice of Zen, not as a religion but as an attitude. "To study the self is to forget the self and become one with ten thousand things," said Dogen.

Even the grounding, the stability, of the physical world tends to skew me too far aloft or adrift sometimes, so much do I love the physical world. The afternoon hikes to the tops of the snowy peaks, and the euphoria, the hyperstimulation of the hunting season, can get me too far from my life in the other direction. Closer to my center, perhaps, but farther from the self I am in the moment, as I move toward that irreducible center we are told lies at the end.

And then, the next morning, the daily descents into that sleeping cave—that bottom place—in which the art gets done; again, one is stretched, perhaps backward this time, attenuating once more perhaps toward one's center and self—as if along the reverse direction of an arc—but nonetheless, further from one's self-in-the-moment, further from the real and the physical.

It's like moonlighting: working two jobs, living in the physical world and the "artsy" world—or, as the character Barton Fink put it, in the movie by that name, dwelling in "the life of the mind." (The weariness that this attenuation, this two-world living can bring reminds me of something Harrison wrote, again in *Just Before Dark*, in his essay, "Poetry as Survival." He writes about a conversation on an airplane: "You tell your seatmate that when he looks in the mirror he might say, 'Jeezo-peezo, I'm getting old,' while Shakespeare said, 'Devouring time, blunt thou lion's paws,' and the latter scans better.")

A thing I do then, for solace and stability, between the drifts and euphorias of writing and hunting, is to

work occasionally on a rock wall I've begun building into the woods, for no real rhyme or reason, and possessing no seeming direction—though I'm sure if I live long enough the thing will somehow circle back around to its beginning.

There are days when I look out at the wall and wonder if the wall is not a physical plug, a stem, against madness, depression, numbness, insensitivity, and dozens of other maladies: that the physical residue, literally tons of detritus arranged and stacked, is the gathering of some ghost-ailment of the soul, and that without those rocks, or my toting of them, I'd be in deep shit.

Such a thought does not tend to make one feel secure or confident about one's ability to exist upright in the world: *Where would I be without rocks,* I tend to wonder, and then I think, *Good thing they're in the world.*

They are so heavy, so square. It soothes me to pick one up—wrapping my arms around it, holding it against my belly—and then to walk a long way with it.

And then the next day—for a few minutes, anyway, or sometimes an hour or two—I feel loose, ready to search for the lithe sinuosity that sentences can find, and to think or work my way a little further into the future, even if only one word at a time.

If you could have seen him run—no matter whether you are a city person, or a country person, sophisticate or bumpkin, beggar or thief—your eyes would

have frozen to a trance, and a chord would have been struck in your heart. You would feel suspended and motionless, and you would have known for several moments nothing but awe and a strange pleasure, just gazing at him. You would have been unable to look away from his beauty, nor at the thing beyond his beauty.

Fifty-five years ago, there was a bird dog in the South named Hillbright Susanna, who people also loved to watch hunt. Half a century later, an account, a testimony, of this dog's style still exists, in a recent article in *The Pointing Dog Journal,* by Tom Davis:

> "A fireball," they [the judges] said. She had the whole package: blinding speed, enormous stamina, ideal range, superior bird-finding ability, and style to burn both running and on point. She was tough as nails, too, bold almost to a fault, but at the same time her personality was vivacious and decidedly feminine.
>
> And if all this weren't enough, she also possessed a special kind of presence, a flair for the dramatic that emphatically set her apart. Whether crossing far to the front on a long, searching cast, joyfully skimming the sedgefields with that effortless gait, or swapping ends to strike point, her response to scent so instantaneous that onlookers blinked in disbelief. . . .
>
> [She was] the dog that people hoarded their wartime gas coupons in order to make the drive to see; the dog whose name was on everybody's

lips, regardless of the outcome of the trial; the dog that etched her luminous image on the memories of every man and woman whoever watched her run.

"You couldn't take your eyes off her," recalls Bob Wehle of Elhew pointer fame, more than half a century later.

If a story can make you feel this way—and of course it can—then what's the difference?

I think the difference, the distance, between art and life, the real anchor, narrows to something less measurable, according to a story's "goodness" or authenticity. Stories *almost* become alive as they more closely approach the thing after which they are modeled. How else to explain the magic that sometimes occurs—this artistic ascent into a thing that is organic—alive and supple and moving and breathing, like a dog or a panther, like a man or a woman or a bird?

We've all seen evidence of this closing-of-the-gap, this approaching-of-life, in our work, and have heard of it in others.

In a story I've been working on for a long time, "Swans," one of the characters, modeled somewhat after a man I know, begins to forget things and becomes lost and confused, and begins trying to drive his truck backward. I was in town one day and was horrified to look out the window and see the individual upon whom parts of this character are based driving backward through the parking lot. I watched for several minutes until I realized he was only searching

for a parking spot—but still, there was a strange leap of terror in my heart, in those first few moments.

In a story, "The Watch," I wrote a somewhat insignificant scene involving two white chickens scurrying about in the woods. The next day, passing that spot in real life, the one I had been trying to describe in the fiction, I saw a truck pause at the intersection, and in its bed were two white chickens. An old man lifted them from the truck and set them down inexplicably—as if in offering—at the edge of the woods.

And of magic, of the past converging with, or galloping, surging, a day or two ahead of the future—what of the chainsawing of my leg that rainy dusk, the evening before Colter disappeared? Did he disappear because I sawed my leg and hence we were not out hunting the next afternoon, safely distanced from whatever events led to his disappearance, or did I saw my leg because my mind or body knew ahead of time that he would be disappearing so soon? The strange collapse of time and space that some say is just ahead of and beyond us.

And what of the old familiar magic of thinking of a person seconds or moments before that person calls; or of dreaming of a letter from someone, and then receiving it the next day, or the next? That happens an awful lot, here in this valley—far more than in other places I've lived. I'm certain these invisible lines of connection follow the real and physical established lines of connection. The fact that nothing's gone extinct in the Yaak—that its full diversity of individuals and relationships is still, even if tenuously,

preserved—provides more avenues, more corridors, for life, and life's potential for "magic," to travel.

Harrison refers me to another quote, this one by Goethe, concerning magic, and the transformation from art to the real and the physical: "Such a price the gods exact for song, to become what we sing."

I argue myself left, I argue myself right. Art, or activism—and if art, what kind? Is the strain of trying to keep the two separate ultimately as debilitating as any imagined detriments brought by mixing the two?

And anyway, isn't it like the old adventure movies where the walls begin closing in, threatening to squash whoever's inside? You can't keep the boundaries from shrinking and compressing through time, can you? Especially not with twice as many concerns; either one alone, art or activism, would by itself be enough to melt you down quick enough.

Wrestle as I will with the question, and try as I might, I cannot separate the two for any longer than a few months at a time—any more than other things in the world can be kept separate. The art feels like lightning and running deer and like the groans and trills and mutters of passing sandhill cranes at night, while the activism feels like pulling a plow, or a stoneboat: an old steel sled pulled by a drafthorse through a raw field.

Each letter to Congress, each activist essay about the Yaak, feels most days like nothing more than another damn piece of wild moraine, ten pounds, *clunk*, into the sled.

You yearn to slip out of the traces and walk light across the field and into the woods.

And here the metaphor falters: for if one truly loves wildness, shouldn't the two be allowed to merge? Or should the field be left stony and uncultivated, ignored and even shunned?

Damned artists—always trying to pretty a place up, and trying to summon some basic plan of order from a far more complex assemblage of order that already exists, but which is simply not yet visible.

When he ran I would picture his blood as shimmering, sparkling almost electrically within, as if in a fountain of sparks, or as if carbonated. Everything his ancestors ever knew was distilled into that blood.

I would sometimes go to him in the field and pet him and praise him for his work, but he had no time for any of that foolishness, not out in the field: he just wanted to hunt.

Art, or activism? Why not both? Why worry about burning out in activism, or failing in art? What else are our lives but diminishing tapers of wax, sputtering already in long flame? Rot or burn, it's all the same to the eye of time.

Writing rule, art rule, Number Eight: this letter from the writer and editor Gordon Lish, returning a poorly written short story I'd sent him. This letter is pinned to my cabin wall; years later, I still read it now and again, and believe it, and appreciate it more with each reading:

Remember . . . what makes art is the occult, the arbitrary, the unexampled, the uncanny, the passionate, the intractible, the dire, the dangerous, the . . .

It's so easy to rein back. It's so easy to sand the edges off a word, and then a sentence, and then a paragraph; then a story; and then, doubtless, a life. It's so easy to rein in a thought. It's so easy to fail.

In hunting with Colter, such was the relief I felt at shedding both the war-coats of author as well as activist that when we would stop for gas and I would buy him a corn dog, I could laugh cleanly at the childish simplicity of my accidental joke—feeding a corn dog to my brown dog—and could laugh too at how much he loved them.

Maybe writers should stay in caves, coming into the village only at night, to take stock—literally. I probably shouldn't have told that, about how much it made me laugh to feed him those corn dogs.

I thought of more writing rules. Number Nine: Weed out whatever adverbs you can, and trust your editors as often as you can. And Number Ten: Always assume the reader is at least as smart as you.

More writer chitchat: Another of my heroes, Barry Lopez, was at a gathering in Montana. There was some kind of little reception where you could pay big bucks to have dinner down by the river with Barry and some political leaders. I went, so that I could talk to the political folks about the Yaak's last roadless

cores: if only to do nothing more than to plant the sound of the word in their ear. The naming of the thing, the problem—the absence.

We were staying at a bed-and-breakfast by the river. For one reason or another I was late to the reception. I went upstairs to drop off my papers and to splash water on my face and change into cleaner, fresher clothes, then hurried downstairs into the social milieu. Barry was swarmed, but presently he was able to make his way free and came over to greet me. He looked stricken, and the first words he spoke to me—we hadn't seen each other in over a year—were in a stage whisper, leaning his head in close to do so. "Your fly is wide open."

I laughed. He's a great practical joker.

"No," he insisted, "it really is."

I zipped up, then, amidst the dignitaries and their spouses, and laughed again. It's an old lesson, but there's no way you can be something you're not. Nearly our whole culture, our whole system of economics, has been structured around the advertising premise that you can—but the biological and hence irreducible truth is you just fucking can't. Vast amounts of money and energy are spent pursuing this fatal illusion. Entire souls are lost in the enterprise. Entire landscapes. I wonder what we will eat, after we have consumed the earth. The stars?

At dinner that night, I was relaxed, having already revealed myself as a woods-savage and not belonging in this place. I sat next to Barry—elegant, eloquent, passionate Barry—and listened to him speak with thunderous intelligence and heart-wrenching

intensity about literature, and morality—everyone was rapt—and when he had finished—everyone at the table was speechless from the power of the message he'd just uttered—I leaned in to him and whispered, "Yourasmartmuhfuh."

Barry frowned. "Beg pardon?" he said.

I repeated it a little clearer, a little louder. "I said, *you're a smart mu'h-fu'h,*" and he shook his head and smiled.

I think it's another useful lesson in art to realize that you can have heroes without being like them. The next day we met after a lecture to go out to lunch. It was storming, so we took my nasty old mud-truck. I had, like a dipshit, left the sunroof open the night before, so that vast quantities of downpour had drenched the truck's upholstery. I found a towel for Barry to sit on, and with a paper towel wiped off the interior nose-smudge from the windshield in front of him, nose-smudge from where the dogs had been riding in his seat. He was ankle-deep in a symphonic clutter of empty Coke cans, and for a couple of moments I stopped thinking of him as my friend, but as Barry Lopez—*he doesn't need this shit*—and when I put the truck in reverse to back out of my parking spot, the reservoir of roof-water that had been resting above us came sloshing down, dumping through the sunroof, dumping a heavy wall of water in our laps— a sheet of it.

I can't stress how important I think it is for a writer to learn to fit his or her skin; and, inseparably, the

cycles and characteristics of the place around that writer.

And then, once you do fit it—your skin, and your place—I can't stress how important I think it is to step out of it. To seek the perimeter, if you are on the interior; or to search for the interior, if you have been camped too long on the perimeter. Once again—I'll say it a third time—in so doing, narrative cannot help but be created. And from the journey of that narrative, understanding.

The price the gods exact for song; it is also the price they exact for life. Two things—any two things, with any difference between them, whether small or great, will always be carving at one another, until some change satisfactory and pleasing to the universe occurs. This is what a story does.

Art, or activism? They shadow one another; they destroy one another: but they share the same inescapable, irreducible bedrock fuel—passion. Love, or fury. Love, and fury. They will always be near one another, in an artist's heart—or the temptation of both of them will always be present, in an artist's heart; and for me, there just came a point one day where I was spending too much energy trying to keep the two apart. It seemed artificial, unnatural, brittle, to have two similar passions, sharing the same root-stock—a reaction against injustice and disrespect—and yet to exclude or excise one of them from my life, for the sake of another, did not feel true or healthy. I would rather fail at both than be disloyal to

one, even if succeeding at the other. It would feel like cheating, like cutting corners—abandoning or disowning or repressing one in order to further the other.

I would rather be ragged-thin and weary than brittle.

The goshawk extracts its shape from the thrush, in following its weaving path through the forest; the thrush extracts its shape from the goshawk, tapering its body toward faster flight. Seen from the corner of one's eye, back in the woods, at dusk, often the predator is mistaken, for a moment, with the prey. The mountain lion stalking the elk: their tan-orange coats are the same color. A patch of fur seen through the forest, butter-colored in October sunlight: lion or elk?

Can hope and desire create physical shapes? The goshawk's desire for the red meat of the thrush's breast sculpt the goshawk? The thrush's desire for freedom sculpt the thrush's shape?

The forest's desire to have birds passing through it shaping both hawk and thrush?

There is almost always a point, some place further back, where two things, seemingly opposed, share root-stock. It is this place, this truth of metaphor, toward which the carver, or the artist, labors: cutting down through conflict and tension toward that place of irreducibility. Two opposing forces are never really anything more than complex shadows of one another, cast from that same deep unalterable place.

Society sculpts artists, as much as we hate to admit it. And artists obviously sculpt civilizations—though society often prefers to think otherwise; believing that, since artists usually remain outside the city walls, society is free to select and choose which art will influence, and which they can ignore.

All the while, the artist—and the activist—keeps carving.

It adds up. Like a thousand freezing nights, or ten thousand, cracking frost-wedges in a field of boulders. Like ten thousand windy days sanding smooth some ridge, so that one day, currents of scent travel down that ridge in a slightly different direction: setting into motion a slightly different chain of events.

Artists can and do sculpt society. We will. Our work is that important—more important than ever as the pace of fracturing accelerates, and few others—neither business-folks nor politicians—step in to help gather up and assist in bringing order, or provide support to those broken pieces.

Just as important as understanding that our work is important—the stories we choose to see, the stories we choose to build—it is good to understand also that we'll never live to see the finished shape of our sculpting. We can dream it in our hearts and can sometimes smell the odor of the fresh-cut wood, can see the wood shavings and stone-grit around our ankles; but even if we live to see that sculpting, we won't live to see how that sculpture performs in the world: how it gets up and moves around. Only the

passing of generations can give it that animation. You have to go to sleep each night satisfied with the work itself—the sculpting—and not the outcome. It is an old lesson but one we must learn again and again. It is a good lesson for both art and activism. I'd have to say that my credo, my advice, is, unless you're like Colter—and I have never met anyone, man or woman, who is—to put your head down and pull the plow.

The place where my old dog used to lie by my cabin— hell, he was only four, but he had an old soul—I have lain there, since his absence, to feel the sun on my own ribs, and to try to take in the scents of the marsh, and to listen to its quiet sounds.

He had lain there so often, and for so long, as I sat in the cabin writing, that in that spot he had compressed the earth to fit the curve of his ribs and haunches; and that bowl, that scoop in the earth, was the shape of joy.

One more credo, then. I don't care if you read my books. I don't care if someone says nice things about them, or mean ones. I've heard plenty of both, and it's just words, wind-drifted and gone-past.

But please, save the last roadless areas in the Yaak.

This valley—the Yaak, and its remaining interior wildness—is the shape of magic.

This valley has more to give than just timber.

Rick Bass

A PORTRAIT

by Scott Slovic

I know a writer with a bomb in his heart. When you meet him, if it's at formal literary gatherings, you'll observe that he is neatly, though informally, dressed—never wearing a coat and tie, but generally a shirt with buttons and clean khaki pants. His sleeves are likely to be rolled halfway up his veined, muscular forearms. He'll have on high-top basketball shoes. This writer's receding, light brown hair is invariably close-cropped. Sometimes there will be stubble on his chin.

When you speak to this man, you'll immediately notice his quiet, polite manner, his shyness. It's as if he's not quite at home anywhere indoors, not even at a gathering of writers, despite his own prominence in such a group. He speaks with a clipped Texas drawl, his accent only slightly diminished after years of living outside his native region. When he gets on stage—a place he's found himself hundreds of times in the past decade—he's likely to spend much of his

allotted time telling you about a strangely named, remote mountain valley where he lives, and he'll use the plainest, bluntest terms he can find to describe what moves him about this place. He'll start his presentation by asking you for something, for your help in saving the last roadless lands in this rugged valley of grizzly bears and mountain lions and bald eagles and dozens of other rare wild creatures. And then, if you're lucky, he'll give you a gift—the gift of a story. Words like "apeshit" and "fucking" roll off his tongue as easily as "beauty" and "metamorphosis" and "love." "Goofy" is his term of inexplicable endearment.

I know a writer with a bomb in his heart. This writer, of course, is Rick Bass. Although he tends to seem controlled and polite in civilized circumstances, any reader of his incandescent prose—fiction or nonfiction—realizes that this artist is a beast, the possessor of a furiously intense imagination and the storytelling voice of a born-and-bred raconteur rather than the studied style of a workshop graduate.

The mind homes in on what it finds most attractive, most important. I recall a time at the 1996 Art of the Wild writers conference in Squaw Valley, California, when Bass joined a panel called "Animal Dreams" together with Brenda Peterson, Alison Deming, and Robert Michael Pyle. The other three speakers offered stirring, eloquent comments on how their own lives had been determined and inspired by contact with such creatures as dolphins and monarch

butterflies and by the possibility of such a creature as Sasquatch. Bass sat through the others' remarks quietly, fidgeting at one end of the table. It seemed to me that he was probably just slightly edgy to be in a closed room and an academic setting—the one hundred or so students and fellow writers in the room were nothing unusual for him. His place on the panel surely was intended to give him the opportunity to tell stories about deer and grizzlies and wolves, as he does so often and so well in his writing. But instead, when it came time for him to speak, he said, contrarily, "I don't know why we always devote so much attention to the megafauna, to the charismatic species, when what's really at issue in the world today is the endangerment of entire interwoven systems. You just can't single out individual species." After five minutes, he concluded, "It's hot in here and I've said enough." No one disagreed—everyone shared his relief at being released into the brilliant sunshine of the Sierras in July.

Following the animal panel, I joined Bass and my nature-writing colleague Michael Branch for an overnight backpacking trip on the Pacific Crest Trail, just up the ridge from the Squaw Valley conference site. Having spent two weeks traveling with Bass the previous summer in Japan, including a three-day trek in the rugged Shirakami Mountains of northern Honshu, I knew what to expect from him on the trail: a breathless, almost nonstop haul from 7,000 feet to nearly 10,000, covering some eight uphill miles in about four hours. When we'd finally set up

camp beside the trail, facing the setting sun and a vast wilderness valley, Bass lamented the incomplete wildness of the place, the fact that in the dimming purple sky we could still make out satellites coursing purposefully among the stars. The next day, after a morning hike and literary discussion, we retraced our steps downhill toward the parking lot and civilization, but just as we departed the high ridge, Bass pointed out a weasel skull amid a tangle of branches and grass—a skull that now sits on the windowsill of my office. "A weasel is wild," Annie Dillard once declared. The mind homes in on what it finds most attractive, and Rick Bass's mind has a built-in wildness sensor.

This desire for wildness is what drew Bass up to the rainy, rugged mountains of northwest Montana in 1987, and various kinds of wildness and intensity are at the heart of his literary art and his environmental activism. Born in Fort Worth, Texas, in 1958, Bass and his brothers (Frank five years younger than Rick, B.J. sixteen years younger) grew up mainly in the western suburbs of Houston, where they took an interest in nature during regular visits to the Museum of Natural History and spent much of their childhood in Buffalo Bayou, "a tiny de facto wilderness between outlying subdivisions," as he describes it in his 1993 essay "On Willow Creek." Their mother, Mary Lucy Robson Bass, took the boys to the Houston zoo often. But as Bass explains in this same essay, and in his first book, *The Deer Pasture* (1985),

much of his intellectual development, his early passion for language and land, occurred not in Houston but in the scrubby, rocky landscape of the Texas hill country, 250 miles to the northwest. "I have to believe," he writes in "On Willow Creek,"

> that somewhere out there is a point where my language—memory—will intersect with the hill country's language: the scent of cedar, the feel of morning mist, the blood of deer, glint of moon, shimmering heat, crackle of ice, mountain lions, scorpions, centipedes, rattlesnakes, and cactus. The cool dark oaks and gold-leaved hickories along the creeks; the language of the hill country seems always to return to water. Along the creeks is where most of the wildlife is found.

Bass learned his deepest childhood lessons about paying attention to a landscape, about loving a place, from childhood hunting trips to Gillespie County, near Fredericksburg, beginning at the age of eight. While walking the thousand acres of his family's deer lease or sitting with his cousins, uncles, father, and grandfather by the evening campfire, he also developed his love of story. This is why we see so insistently in his recent conservation writings the argument that wild places and good art go hand in hand—because in Bass's own life, these are twin loves. "When we run out of country, we will run out of stories," he claims. And: "When we run out of stories, we will run out of sanity."

Bass left Houston to attend college at Utah State University in Logan, where he played flanker and

tailback on the junior varsity football team and studied whatever he thought might eventually enable him to live a life in the woods. He began as a wildlife biology major, but ended up in petroleum geology, following in the footsteps of his father, C. R. Bass. Along the way, Bass studied essay writing with Thomas J. Lyon, the prominent nature writing scholar and anthologist. Bass moved to Mississippi, after graduating from Utah State in 1980, to take a job for a petroleum prospecting company. But he quickly realized that what he really wanted to do was tell stories. So he taught himself to write by reading voraciously—especially fiction by Barry Hannah, Jim Harrison, and Eudora Welty—and spending hours every day sitting at a table in the middle of a field near his country house, just writing.

Although *The Deer Pasture,* a collection of narrative essays, was published in 1985, his first significant fiction appeared in 1987, when the *Paris Review* published the long story called "Where the Sea Used to Be," which evolved into a three thousand-page novel manuscript over the course of fourteen years and for which Bass received a 1997–98 Guggenheim Fellowship in order to complete his revisions.

In 1987, Bass's second book of nonfiction, *Wild to the Heart,* appeared. The essays in this book, such as "Shortest Route to the Mountains" and "On Camp Robbers, Rock Swifts, and Other Things Wild to the Heart" and "River People," range geographically from Mississippi to North Carolina, and from Alabama to Utah. Mostly this early work demonstrates the

rhapsodist's love of wild places and indicates Bass's yearning to live in a place where wildness is within his everyday reach and does not require mad, weekend driving marathons from Mississippi to the mountains of New Mexico. Celebration is the dominant mood of this collection, whether the object of celebration is a strawberry milkshake from the Lake Providence, Louisiana, Sonic Drive-In or white water on the Nantahala River in North Carolina. But Bass's defensive, conservationist predilection also emerges when he writes:

> If it's wild to your own heart, protect it. Preserve it. Love it. And fight for it, and dedicate yourself to it, whether it's a mountain range, your wife, your husband, or even (heaven forbid!) your job. It doesn't matter if it's wild to anyone else: if it's what makes your heart sing, if it's what makes your days soar like a hawk in the summertime, then focus on it. Because for sure, it's wild, and if it's wild, it'll mean you're still free. No matter where you are.

The same year *Wild to the Heart* came out, though, Bass and his girlfriend Elizabeth Hughes, an artist whose pen-and-ink sketches illustrate several of his books, were no longer content to find wildness in Mississippi and hit the road with their two hound dogs, Homer and Ann, in their old truck, searching for a place in the West wild enough to sustain their art. He later described this search in his 1991 book *Winter: Notes from Montana* and in several of the essays, such as "The Value of a Place," from the 1996

volume *The Book of Yaak*. Although they were originally headed for New Mexico, they didn't find what they were looking for until they reached the isolated, little-known northwest corner of Montana, nearly at the Canadian border. They had found the Yaak Valley.

Although he was already living in Montana, Bass's next two books, a nonfiction journal called *Oil Notes* and his short story collection *The Watch*, came out in 1989 and mostly emphasized his experiences in the South. *Oil Notes* begins to explore what has since become an ongoing motif in his work: the relation between science and art, including the artfulness of science. In an aside about how an illiterate bully named Jimbo once taught him to throw a baseball, Bass also reflects on teaching and sharing. "He was trying to share everything he had about it in as few words as possible," the writer explained in a later interview, "and trying to transcend the difference between us in order to share the subject—and it was a gift. And yeah, I think the best writing shares that same passion, that almost desperate passion." The characters in *The Watch* range from nouveau riche Houstonites to an ambivalent Mormon girl in Utah, but perhaps the most memorable, aside from the seventy-seven-year-old Buzbee in "The Watch" who flees society to live with a harem of women hiding out from abusive husbands in a mosquito-and-alligator-filled Mississippi bayou, is Galena Jim from the story "Choteau." Jim and the story's first-person narrator hunt together in the Yaak Valley in the fall,

but when it's not hunting season, they seek something else, something on the verge of recklessness and criminality—something like wildness itself. In the climactic scene of the story, Jim leaps from his pickup at forty miles per hour onto the back of a bull moose. "No one was around to see any of this. I couldn't understand why he was doing it," says the narrator. But later in the night, as they return home, he notices that "the road sparkled and glittered in front of us, a path of where Jim had once been; a road one might encounter only in a dream." The wilder the place and the action and the characters, in other words, the more invigorated the imagination becomes; and yet there is also a sense here of characters in decline, not quite able to live up to their dreams. A Dickeyesque love of violent, vigorous *reality* permeates these stories.

Bass married Elizabeth Hughes in 1991, and that same year *Winter* was published, recounting in journal format the first winter (1987–88) that they had spent in the Yaak Valley. This is the book of a neophyte, a southerner stuck for the first time in the northern mountains during winter; but it is also a book about becoming familiar with a new place and, indeed, falling in love with place. It is possible to chart Bass's own progress from bewilderment and discomfort to love, and eventually to fierce protectiveness by reading his series of books about Montana and the Yaak that begins with *Winter*. In 1992, Bass's daughter Mary Katherine was born, followed by a second daughter, Lowry Elizabeth, in 1995; the

arrival of his children has coincided closely with the increasing emphasis in his writing on various forms of protectiveness and on the Yaak-as-home motif.

Two years after *Winter* was published, Bass came out with *The Ninemile Wolves,* a chronicle of the return of wild wolves to Pleasant Valley, a sheep and cattle region between Glacier National Park and the town of Libby in northwestern Montana. As one might expect, Bass celebrates the return of wolves to this place, not far from his home in the Yaak. His language to describe wolves—"All they've got is teeth, long legs, and—I've got to say this—great hearts"—is reminiscent of the very language he uses to describe his beloved hunting dog, Colter, in this new book for the *Credo* Series. Although conversant in the technical language of wildlife biology, Bass prefers in this book—and other wildlife-oriented essays—to use the discourse of emotion and imagination. "There is an electricity, a tension going on inside the wolves," he states in the epilogue ("Wise Blood") to his first wolf book:

> the actual physics of it probably fitting into some undiscovered formula, if one cares to go in that direction—a flow of sparks across a gap of too much and not enough, between "good" and "bad."
>
> I have come away from following the Ninemile wolves convinced that to diminish their lives would be wicked; that it would involve a diminishing of a significant force in the world, that it would slow the earth's potential

and cripple our own species' ability to live with force; that without the Ninemile wolves, and other wolves in the Rockies there would be a brown-out, to extend the metaphor of electricity; that the power would dim, and the bright lights of potential—of strength in the world— would grow dimmer.

The existence of wild creatures in wild places, Bass suggests, is important not only to rural dwellers like himself but to all of human civilization. This is a vigorous extension of Edward Abbey's famous claim in *Desert Solitaire* that "we need wilderness whether or not we ever set foot in it. We need a refuge even though we may never need to go there. . . . We need the possibility of escape as surely as we need hope. . . ." The wolves' tenuous return to Montana is, for Bass, a sign of crucial hope. He extended his examination of wolf reintroduction by publishing, in 1998, *The New Wolves: The Return of the Mexican Wolf to the American Southwest.*

In 1994, three novellas ("Mahatma Joe," "Field Events," "Platte River") were published in the collection *Platte River.* The first story is a study of zeal and belief and how these traits can lead an individual—in this case a wilderness preacher—to influence his family and community in either healthy or adverse ways. "Field Events," set uncharacteristically in upstate New York (a part of the country Bass came to know in the summer of 1983 when he attended the Bread Loaf writers workshop in nearby Vermont), celebrates the prodigious, magical strength of a discus thrower, who

is an artist of the body, a lover of the physical universe. The title piece of the collection tells the story of a retired football lineman who visits an old teammate at an art school in northern Michigan; the main character, Harley, has spent his whole life mustering every bit of his physical strength to protect other people, running backs and girlfriends and depressed acquaintances, but he learns in this story that sometimes there are things that don't need his protection. It is clear that Bass, too, is intensely driven to defend what he cares about, and this work of fiction shows him testing the issue of when to protect and when to let go. Ten more short stories then appeared in the collection *In the Loyal Mountains* in 1995; for his subject matter, Bass reaches back into his Houston childhood ("Swamp Boy"), returns again to his beloved hill country ("In the Loyal Mountains"), and thinks about life in the Yaak Valley ("The Valley" and other stories) in a narrative mode that verges on nonfiction.

Also in 1995, Bass published another book of nonfiction entitled *The Lost Grizzlies: A Search for Survivors in the Colorado Wilderness*. Much of this book relates the author's experiences in the San Juan range of southern Colorado with wildlife scientists from the Round River School of Conservation Studies, seeking evidence of a remnant grizzly bear population in a region where no such animals have been witnessed with certainty for nearly two decades. Much of this book is an adventure story, recounting not only the group's quest for traces of elusive bears but also offering a compelling character sketch of

Doug Peacock (author of the 1990 book *Grizzly Years: In Search of the American Wilderness),* whom Bass and the Round River faculty and students accompanied on several trips to the San Juan range. This book is a logical extension of *The Ninemile Wolves,* although in this story the persistence of wildness is even more subtle and doubtful than in the earlier case.

Bass then published a collection of nonfiction magazine pieces about his home in Montana called *The Book of Yaak.* Much of this volume is directly related to the subject matter of Bass's *Credo* essay, for it addresses quite explicitly the relationship between the writer's art and his activism, although with less consistency and thoroughness than in the present book. *The Book of Yaak,* he says in the introduction, is:

> a sourcebook, a handbook, a weapon of the heart. To a literary writer, it's a sin, to ask something of the reader, rather than to give; and to know the end, to know your agenda, from the very start, rather than discovering it along the way, or at the end itself.

Readers may be reminded here of the final chapter of Terry Tempest Williams's *Refuge: An Unnatural History of Family and Place,* where the author tells an arresting officer at the Nevada Test Site that her pen and paper are "weapons." Bass, too, has realized increasingly during his busy career that if he cares about what he sees happening in the world, what's threatened or disappearing, he needs to act directly to protect these things. "The Blood Root of Art" discusses

some of the issues that emerge in this *Credo* essay—in particular, the question of how an artist should behave when he witnesses problems in the world. "Writing—like the other arts—is not a hobby, but a way of living," Bass asserts. But in making the choice of what kind of writing to pursue, the artist may be compromising his own imaginative energy, may be sacrificing beauty and suppleness for the shrill, brittle plea of the activist. One of Bass's most eloquent articulations of the strain of combining these divergent goals, these competing sensibilities, is the extraordinarily hybridized fiction-nonfiction narrative entitled "Fiber" that was published as a slim book by the University of Georgia Press in 1998.

Indicating that he has not been forced to abandon altogether his artistic work in pursuit of the activist agenda, Bass published three more novellas ("The Myths of Bears," "Where the Sea Used to Be," and "The Sky, the Stars, the Wilderness") in the collection *The Sky, the Stars, the Wilderness* in 1997. And in 1998, he completed his fourteen-year labor on the vast novel, *Where the Sea Used to Be,* which tells the story of a geologist father and his biologist daughter, establishing two divergent paradigms for considering the natural world, the vertical, exploratory mode, and the horizontal, accommodating perspective. A ubiquitously anthologized writer, and one whose fiction and essays appear routinely in such publications as the *Paris Review, Esquire, Audubon, Outside, Sierra, Orion, Harper's, Double Take,* and many others, Bass has demonstrated not only a unique literary and activist

voice, but virtually unprecedented energy in pursuit of his craft and his causes.

Several years ago, when I was completing my term as founding president of the Association for the Study of Literature and Environment (ASLE), I received an irate letter from a professor somewhere in the northeast who was upset that her name had been taken from the ASLE membership directory and given to a crazed person named Rick Bass, the author of a series of hastily typed, frenzied letters asking ASLE members and others on his mailing list to tell their congressmen, "Don't hack the Yaak." Bass, a founding member of the ASLE advisory board, had indeed photocopied the organization's mailing list, cut out each name and address, taped all six hundred or so to envelopes, and then enclosed his protect-the-Yaak missives. In response to this agitated individual, I explained that Rick Bass is one of the most respected contemporary American nature writers and fiction writers, and in addition to his artistic efforts, he spends much of his time (and money) working to protect the natural world, particularly the Yaak Valley.

If readers of environmental literature hope to understand what this form of writing is all about, what passions and fears motivate these artists, they need look no further than Rick Bass for a splendid example. This writer has a bomb in his heart—such is the incandescence within him.

BIBLIOGRAPHY OF
RICK BASS'S WORK

by Scott Slovic

BOOKS

Fiber. Athens: University of Georgia Press, 1998.

The New Wolves: The Return of the Mexican Wolf to the American Southwest. New York: The Lyons Press, 1998.

Where the Sea Used to Be. Boston: Houghton Mifflin, 1998.

The Sky, the Stars, the Wilderness. Boston: Houghton Mifflin, 1997.

The Book of Yaak. Boston: Houghton Mifflin, 1996.

In the Loyal Mountains. Boston: Houghton Mifflin, 1995. Paris: Christian Bourgois, 1996 (French edition).

The Lost Grizzlies: A Search for Survivors in the Colorado Wilderness. Boston: Houghton Mifflin, 1995.

Platte River. Boston: Houghton Mifflin/Seymour Lawrence, 1994. New York: Ballantine, 1995 (paperback). Paris: Christian Bourgois, 1996 (French edition).

The Ninemile Wolves. Livingston, Mont.: Clark City Press, 1992. New York: Quality Paperback Book of the Month Club, 1992 (paperback). New York: Ballantine, 1993 (paperback). Tokyo: Shobunsha, 1995 (Japanese edition).

Winter: Notes from Montana. Boston: Houghton Mifflin/Seymour Lawrence, 1991. Taipei: Monsoon, 1993 (Chinese edition). Milan: Feltrinelli, 1997 (Italian edition).

Oil Notes. Boston: Houghton Mifflin/Seymour Lawrence, 1989. London: Collins, 1989. Milan: Serra e Riva, 1989 (Italian edition). Boston: Houghton Mifflin/Seymour Lawrence, 1990 (paperback). London: Flamingo, 1990 (paperback). Dallas: Southern Methodist University Press, 1995 (paperback).

The Watch. New York: Norton, 1989. New York: Quality Paperback Book of the Month Club, 1989 (paperback). New York: Washington Square Press, 1990 (paperback). New York: Norton, 1994 (paperback). Paris: Christian Bourgois, 1996 (French edition).

Wild to the Heart. Harrisburg, Pa.: Stackpole Books, 1987. New York: Norton, 1989 (paperback). New York: Norton, 1997 (paperback). Tokyo: Hakusui-Sha, 1994 (Japanese edition).

The Deer Pasture. College Station: Texas A&M University Press, 1985. New York: Norton, 1989 (paperback). New York: Norton, 1996 (paperback). Texas A&M University Press, 1999 (paperback).

JOURNAL, MAGAZINE, AND NEWSPAPER PUBLICATIONS

"Paris." *Paris Review,* no. 150 (Spring 1999).

"Meat." *Bugle* (January/February 1999).

"Why I Came West and Why I Stayed." *Canyon Keeper* (publication of the North Fork Preservation Alliance) (Fall/Winter 1998–1999).

"The Comet." *Hayden's Ferry Review* (Fall/Winter 1998–1999).

"The Kootenai Five." *Whole Terrain* 7 (1998/1999).

"A Dangerous Triangle." *Sports Afield* (November 1998).

"Protecting the Big Wild." *Inner Voice* (September/October 1998).

"Seams of Memory, Ribbons of Brush." *Gray's Sporting Journal* (Fall 1998).

"Into the Fire." *Men's Journal* (August 1998).

"Crossing the Backbone of the World." *Sports Afield* (August 1998).

"The Bear." *Bomb* (Summer 1998).

"Into the Shirakamis." *ISLE* 5, no. 2 (Summer 1998).

"The Hermit's Story." *Paris Review* (Summer 1998).

"Cores." *Appalachia* (June 15, 1998).

"Four Coyotes." *Appalachia* (June 15, 1998).

"Eating Montana." *Amicus Journal* (June 1998).

"His Parents." *Pointing Dog Journal* (May/June 1998).

"Grad School." *Shooting Sportsman* (May/June 1998).

"Two Bars." *Big Sky Journal* (Spring 1998).

"'Temporary' Roads Bring Permanent Damage." *Anchorage Daily News* (January 25, 1998).

"Hastily Built Roads Damage Nation's Forests." *Seattle Post-Intelligencer* (January 18, 1998).

"France." *Five Points* (Winter 1998).

"Fiber." *Mississippi Review* (1998).

"First Pheasant." *Sports Afield* (November 1997).

"Hold Nothing Back." *Sierra* (September/October 1997).

"Two Deer." *Fish Stories* (Fall 1997).

"Rust." *Five Points* (Summer 1997).

"Round River." *Orion* (Summer 1997).

"Romania." *Terra Nova* 2, no. 2 (Spring 1997).

"Bearing Witness." *Audubon* (January/February 1997).

"The Myths of Bears." *Southern Review* 33, no. 1 (Winter 1997).

"Real Town." *Epoch* 46, no. 1 (1997).

"Healing." *Journal of Land Resources and Environmental Law* 17, no. 2 (1997).

"The Blood Root of the Yaak." *Orion Afield* 1, no. 1 (1997).

Excerpt from "Antlers." *Wild Duck Review* (December 1996).

"The Value of a Place." *Wild Duck Review* (December 1996).

"The Prisoners." *Hayden's Ferry Review* (Fall/Winter 1996).

Excerpts from *The Book of Yaak*. *Big Sky Journal* (Fall 1996).

"The Perfect Day." *Five Points* (Fall 1996).

Conservation introduction. *Montana Magazine* (Fall 1996).

"Saving Logan Canyon." *Salt Lake City Magazine* (Fall 1996).

"The Fringe." *Sonora Review* (Fall 1996).

"The Storekeeper." *Southern Review* (Fall 1996).

"A Plea from a Moderate Conservationist." *Des Moines Register* (August 21, 1996).

"A Passion for Trees: Moderate Pleads for Help to Repeal 'Clear-Cut Rider'." *Phoenix Gazette* (August 20, 1996).

"Rosalind's Woods." *Audubon* (July/August 1996).

"Field Truths." *Sierra* (July/August 1996).

Introduction to flyfishing issue. *Big Sky Journal* (Spring 1996).

"The Blood Root of Art." *Eugene Weekly* (February 29, 1996).

"My Congressman." *Harper's* (February 1996).

"My Grizzly Story." *Audubon* (January/February 1996).

"Some Safe Place." *Double Take* (Winter 1996).

Excerpts from *The Book of Yaak. Wild Earth* (Winter 1996).

"Antlers." *AFSEEE* (1996).

"My Congressman." *Witness* (1996).

"Untouched Country." *Outside* (December 1995).

"The Fires Next Time." *Audubon* (September/October 1995).

"Links in a Chain." *Sports Illustrated* (June 26, 1995).

"America's Predators." *Sports Afield* (June 1995).

"Counting Caribou." *Audubon* (May/June 1995).

"Yaak: The Land that Congress Forgot." *Montana Magazine* (May/June 1995).

"The Perfect Day." *Sierra* (May/June 1995).

"Home." *Orion* (Spring 1995).

"Almost Like Hibernation." *House Beautiful* (February 1995).

"Thunder and Lightning." *Sierra* (January/February 1995).

"This Savage Land." *Big Sky Journal* (Winter 1995).

"Two Deer." *Paris Review* (Winter 1995).

"Making a Case for the Yaak." *AFSEEE* (1995).

"Into the Grizzly Hilton." *Sports Afield* (December 1994).

"Records." *Sports Afield* (December 1994).

"Logan Canyon Road: Time to Stop." *Audubon* (November/December 1994).

"Swamp Boy." *Beloit Fiction Journal* (Fall 1994).

"The Earth Divers." *Weber Studies* (Fall 1994).

"Creatures of the Dictator." *Men's Journal* (April 1994).

"Out on the Wild Fringe." *Audubon* (January/February 1994).

"The Woods Where I Live." *Scholastic Scope* (January 14, 1994).

"On Willow Creek." *Los Angeles Times Magazine* (November 28, 1993).

"Colorado Grizzlies: Are They Out There?" *Audubon* (September/October 1993).

"Beloit." *Mississippi Review* (Fall 1993).

"Mahatma Joe." *Mississippi Review* (Fall 1993).

"Paradise Rising." *Conde Nast's Traveler* (June 1993).

"House 20515/Senate 20510." *American Nature Writing Newsletter* (Spring 1993).

"Ironwood." *Antioch Review* 50, no. 4 (Fall 1992).

"The Literature of Loss." *Manoa* 4, no. 2 (Fall 1992).

"The Windy Day." *Quarterly* 23 (Fall 1992).

"On Grizzly Peak." *Los Angeles Times Sunday Magazine* (August 2, 1992).

"Platte River." *Paris Review* (Winter 1992).

"The Valley." *American Short Fiction* 8 (1992).

"Crossing Over." *Petroglyph* 4 (1992).

"The Way Wolves Are." *Icarus* (Fall 1991).

"Four Coyotes." *Northern Lights* (Fall 1991).

"Days of Heaven." *Ploughshares* 17, nos. 2/3 (Fall 1991).

"Rick Bass to Q." *Quarterly* 19 (Fall 1991).

"The Wolves' Story." *Outside* (October 1991).

"Perspectives on the Hunt." *Parabola* 16, no. 2 (Summer 1991).

"Origins." *Hayden's Ferry Review* 8 (Spring/Summer 1991).

"Fishing Out of Water." *Discovery Channel Magazine* (May 1991).

Selections from *Winter. Sonora Review* (Winter 1991).

"Antlers." *Special Report* (November 1990–January 1991).

"Why I Hunt." *Esquire* 114 (October 1990).

"The Legend of Pig-Eye." *Paris Review* (Summer 1990).

"In the Loyal Mountains." *Southwest Review* 75 (Summer 1990).

"Fires." *Quarterly* 13 (Spring 1990).

"The Wait." *Story* 38 (Spring 1990).

"Susan." *Quarterly* 16 (Winter 1990).

"Without Safety: Writing Nonfiction." *Columbia* 15 (1990).

"A Dog in the Hand." *Esquire* 112 (October 1989).

"Notes from Yaak." *Antaeus* 63 (Autumn 1989).

"Without Safety: Writing Nonfiction." *Hayden's Ferry Review* 5 (Fall 1989).

"Field Events." *Quarterly* 11 (Fall 1989).

"Yazoo." *Southern Review* 25 (Autumn 1989).

"Penetrations." *Story* 37 (Fall 1989).

"After Oil." *Harper's* 278 (May 1989).

"Shyness." *Black Warrior Review* 15, no. 2 (Spring 1989).

"Rick Bass to Q." *Quarterly* 9 (Spring 1989).

"Seven Day Cowboy." *Traveler* 24 (March 1989).

"May." *Quarterly* 12 (Winter 1989).

"The Afterlife." *Witness* 3, no. 4 (Winter 1989).

"Valley of the Crows." *Witness* 3, no. 4 (Winter 1989).

"Wejumpka." *Chariton Review* 15, no. 1 (1989).

"The History of Rodney." *Ploughshares* 15, nos. 2/3 (1989).

"Choteau." *Gentleman's Quarterly* 58 (December 1988).

"An Oilman's Notebook: *Oil Notes*." *Antaeus* 61 (Autumn 1988).

"Redfish." *Esquire* 110 (August 1988).

"Wild Horses." *Paris Review* (Summer 1988).

"Ready, Almost Ready." *Quarterly* 6 (Summer 1988).

"Rick Bass to Q." *Quarterly* 6 (Summer 1988).

From *Oil Notes*. *Southwest Review* 73 (Summer 1988).

"Mexico." *Antaeus* 60 (Spring 1988).

"Meat." *Quarterly* 5 (Spring 1988).

"Those Twisting Things." *Quarterly* 8 (Winter 1988).

"Dilution." *Kansas Quarterly* 20, no. 3 (1988).

"The Watch." *Quarterly* 3 (Fall 1987).

"Mississippi." *Cimarron Review* (Summer 1987).

"Juggernaut." *Quarterly* 2 (Summer 1987).

"The Government Bears." *Southern Review* 23 (Summer 1987).

"Other." *Southern Review* 23 (Summer 1987).

"Where the Sea Used to Be." *Paris Review* (Spring 1987).

"Cats and Students, Bubbles and Abysses." *Carolina Quarterly* 39, no. 2 (1987).

BOOK INTRODUCTIONS

California Grizzly by Tracy I. Storer and Lloyd P. Tevis, Jr. Berkeley: University of California Press, 1996.

Traveling at High Speeds by John Rybicki. Kalamazoo: Western Michigan University Press, 1996.

The Wolf Almanac by Robert H. Busch. New York: Lyons and Burford, 1995.

Adventures with a Texas Naturalist by Roy Bedichek. Reprint, Austin: University of Texas Press, 1994.

Boomerang and Never Die: Two Novels by Barry Hannah. Oxford: University of Mississippi Press, 1994.

ANTHOLOGY APPEARANCES

"Days of Heaven." In *The Literary West: An Anthology of Western American Literature,* edited by Thomas J. Lyon. New York: Oxford University Press, 1999.

"Lion Story." In *Shadow Cat: Encountering the American Mountain Lion,* edited by Susan Ewing and Elizabeth Grossman. Seattle: Sasquatch Books, 1999.

"A Good Day at Black Creek." In *The Woods Stretched for Miles: New Nature Writing from the South,* edited by John Lane and Gerald Thurmond. Athens: University of Georgia Press, 1999.

"The Heart of a Forest." In *Best Spiritual Writing 1998.* San Francisco: HarperCollins, 1998.

"My Daughters." In *Fathering Daughters: Reflections by Men,* edited by DeWitt Henry and James Alan MacPherson. Boston: Beacon Press, 1998.

"On Willow Creek." In *Literature and the Environment,* edited by Lorraine Anderson, Scott Slovic, and John P. O'Grady. New York: Addison Wesley Longman, 1998.

"Fiber." In *Off the Beaten Path: Stories of Place,* edited by Joseph Barbato and Lisa Weinerman-Horak. New York: Farrar, Straus and Giroux, 1998.

"The Myths of Bears." In *Prize Stories 1998: The O. Henry Awards*. New York: Anchor Books, 1998.

"Ecosystem Management, Wallace Stegner, and the Yaak Valley of Northwestern Montana." In *Reclaiming the Native Home of Hope: Community, Ecology, and the American West*, edited by Robert B. Keiter. Salt Lake City: University of Utah Press, 1998.

"This Savage Land." In *The River Reader*, edited by John A. Murray. New York: The Lyons Press, 1998.

"Antlers." In *Fiction 100*, edited by James Pickering. New York: Simon and Schuster, 1997.

"Journal Excerpts." In *The Writer's Life*, edited by Carol Edgarian and Tom Jenks. New York: Vintage, 1997.

"Fires." In *Best American Stories*, edited by Katrina Kennison and John Edgar Wideman. Boston: Houghton Mifflin, 1996.

"The Fourth of July Dash." In *The Best of Sports Afield*, edited by Jay Cassell. New York: Atlantic, 1996.

"The Watch." In *Best of the South*, edited by Anne Tyler. Chapel Hill: Algonguin Books, 1996.

"Mountain Secrets" (excerpt from "Magic at Ruth Lake" in *Wild to the Heart*). In *Echoes from the Summit*, edited by Paul Schullery. San Francisco: Sierra Club, 1996.

"Yaak Valley Jalapeño Chicken and Dumplings." In *Famous Friends of the Wolf Cookbook: Benefiting Wolf Recovery in the West*, edited by Nancy Reid. Holbrook, Mass.: Adams Media Corporation, 1996.

"Getting It Right." In *Headwaters: Montana Writers on Water and Wilderness*, edited by Annick Smith. Missoula: Hellgate Writers, 1996.

"An Appeal to Hunters." In *A Hunter's Heart: Honest*

Essays on Blood Sport, edited by David Petersen. New York: Henry Holt, 1996.

"My Grizzly Story" (excerpt). In *Mark of Bear,* edited by Paul Schullery. San Francisco: Sierra Club, 1996.

"Untouched Country." In *Testimony: Writers of the West Speak On Behalf of Utah Wilderness,* edited by Stephen Trimble and Terry Tempest Williams. Minneapolis: Milkweed Editions, 1996.

"Creatures of the Dictator." In *American Nature Writing 1995,* edited by John Murray. San Francisco: Sierra Club, 1995.

"On Willow Creek." In *The Geography of Hope,* edited by Joseph Barbato and Lisa Weinerman. New York: Pantheon/Vintage, 1995.

"On Willow Creek." In *Heart of the Land,* edited by Joseph Barbato and Lisa Weinerman. New York: Pantheon, 1995.

"Wild Horses." In *The Literary Horse,* edited by Lilly Golden. New York: Atlantic Monthly Press, 1995.

"Almost Like Hibernation." In *Thoughts of Home,* edited by Elaine Greene. New York: Hearst Books, 1995.

"The Odyssey." In *Unleashed,* edited by Amy Hempel and Jim Shepard. New York: Crown, 1995.

"The Fringe." In *American Nature Writing 1994,* edited by John Murray. San Francisco: Sierra Club, 1994.

"September 20." In *Green Perspectives,* edited by Walter Levy and Christopher Hallowell. New York: HarperCollins, 1994.

"The Valley." In *Listening to Ourselves,* edited by Alan Cheuse and Caroline Marshall. New York: Anchor, 1994.

"Antlers." In *Texas Bound*. Dallas: Southern
 Methodist University Press, 1994.

"Hawaii." In *A Thousand Leagues of Blue,* edited by
 John Murray. San Francisco: Sierra Club, 1994.

"To Be Allowed to Live." In *Wolf Songs: The Classic
 Collection of Writings about Wolves,* edited by
 Robert Busch. San Francisco: Sierra Club, 1994.

"The Nantahala" (excerpt from "River People" in
 Wild to the Heart). In *Being in the World: An
 Environmental Reader for Writers,* edited by Scott H.
 Slovic and Terrell F. Dixon. New York: Macmillan,
 1993.

"Drilling for Oil." In *The Compact Reader,* edited by
 Jane E. Aaron. Boston: Bedford Books of St.
 Martin's Press, 1993.

"Why I Hunt." In *Crossfire: An Argument Rhetoric and
 Reader,* edited by Gary Goshgarian and Kathleen
 Krueger. New York: HarperCollins, 1993.

"Heartwood." In *Dreamers and Desperadoes,* edited by
 Craig Lesley. New York: Bantam Doubleday Dell,
 1993.

"Susan." In *New Growth Two,* edited by Mark Busby.
 San Antonio: Corona, 1993.

"The History of Rodney." In *Other Sides of Silence:
 New Fiction from Ploughshares,* edited by Dewitt
 Henry. Winchester, Mass.: Faber and Faber, 1993.

"The Way Wolves Are." In *Out Among the Wolves:
 Contemporary Writings on the Wolf,* edited by John
 Murray. Seattle: Alaska Northwest, 1993.

"Days of Heaven." In *The Pushcart Prize Eighteen,*
 edited by Bill Henderson. New York: Pushcart,
 1993.

"Valley of the Crows." In *Searching Out the
 Headwaters: Change and Rediscovery in Western*

Water, edited by David H. Getches, Charles F. Wilkinson, Lawrence J. MacDonnell, and Sarah F. Bates. Washington, D.C.: Island Press, 1993.

"Traffic Rogues of Richmond." In *State Lines,* edited by Ken Hammond. College Station: Texas A&M University Press, 1993.

"Days of Heaven." In *Best American Short Stories,* edited by Robert Stone and Katrina Kennison. Boston: Houghton Mifflin, 1992.

"The Other Fort Worth Basses." In *Fathers and Sons,* edited by David Seybold. New York: Weidenfeld and Nicholson, 1992.

"The Grizzly Cowboys." In *The Great Bear,* edited by John Murray. Seattle: Alaska Northwest, 1992.

"Sipsey in the Rain." In *New Nature Writers for the Nineties,* edited by John Murray. Golden, Col.: Fulcrum, 1992.

"The Afterlife." In *On Nature's Terms,* edited by Thomas J. Lyon and Peter Stine. College Station: Texas A&M University Press, 1992.

"Valley of the Crows." In *On Nature's Terms,* edited by Thomas J. Lyon and Peter Stine. College Station: Texas A&M University Press, 1992.

"The Legend of Pig-Eye." In *Best American Short Stories,* edited by Alice Adams and Shannon Ravenel. Boston: Houghton Mifflin, 1991.

"Antlers." In *The Best of the West Four,* edited by James and Denise Thomas. New York: Norton, 1991.

"In the Loyal Mountains." In *New Stories from the South: The Year's Best in 1991,* edited by Shannon Ravenel. Chapel Hill: Algonquin Books, 1991.

"Heartwood." In *The Sound of Writing,* edited by Alan Cheuse and Caroline Marshall. New York: Anchor, 1991.

"The Wait." In *Boats,* edited by David Seybold. New York: Weidenfeld and Nicholson, 1990.

"The History of Rodney." In *New Stories from the South: The Year's Best 1990,* edited by Shannon Ravenel. Chapel Hill: Algonquin Books, 1990.

"Wejumpka." In *The Pushcart Prize Fifteen,* edited by Bill Henderson. New York: Pushcart, 1990.

"Heartwood." In *The Best of the West Three: New Stories by Texas Writers,* edited by Lyman Grant. San Antonio: Corona, 1989.

"Wejumpka." In *New American Short Stories 1989: The O. Henry Awards,* edited by William Abrahams. New York: Doubleday, 1989.

"Other." In *New Growth: Contemporary Short Stories by Texas Writers,* edited by Lyman Grant. San Antonio: Corona, 1989.

"Wild Horses." In *New Stories from the South 1989,* edited by Shannon Ravenel. Chapel Hill: Algonquin Books, 1989.

"The Watch." In *New Stories from the South 1988,* edited by Shannon Ravenel. Chapel Hill: Algonquin Books, 1988.

"Where the Sea Used to Be." In *The Pushcart Prize Thirteen,* edited by Bill Henderson. New York: Pushcart, 1988.

"The Deer Pasture." In *Tales from Gray's,* edited by Ed Gray. Augusta, Ga.: Gray's Sporting Journal Press, 1987.

SOUND RECORDINGS

"Some Safe Place." Read by the author. National Public Radio, December 1997.

"Fires." Read by Ted Marcoux. For *Selected Shorts,*

Symphony Space, 1994. (2537 Broadway at 95th St., New York, NY 10025; 212-864-1414.)

"Antlers." Read by Sean Hennigan. Dallas Museum of Art, March 9, 1992. (Stored for archival purposes.)

The Deer Pasture and *Wild to the Heart,* excerpts. Read by the author. The Audio Press, 1992. (Now owned by Northword Press, Box 1360, Minocqua, WI 54548; 715-356-9800.)

Oil Notes. Read by the author. HarperCollins, 1990. (Caedmon no. 06-29-1820-90. 10 East 53rd St., New York, NY 10022.)

INTERVIEWS

Breen, Kevin. "An Interview with Rick Bass." *Poets and Writers* (May 1, 1993).

Bushnell, Jeremy P. *Sonora Review* (Spring/ Summer 1998).

Crowe, Judy, and Casey Walker. "Interview: Rick Bass." *Wild Duck Review* (December 1996).

Johnson, K. C. "What the Woods Would Expect of You: An Interview with Rick Bass." *Sycamore Review* 9, no. 1 (Winter/Spring 1997). Reprinted in *Delicious Imaginations: Conversations with Contemporary Writers,* edited by Sarah Griffiths and Kevin Kehrwald. West Lafayette: Purdue University Press, 1998.

Lyons, Bonnie. "Out of Boundaries: An Interview with Rick Bass." *New Letters* (1993).

Morris, Anne. "Love of the Word, Love of the Land." *Austin American-Statesman* (November 26, 1993).

Murray, John. "Of Winter and Wilderness: A Conversation with Rick Bass." *Bloomsbury Review* (April/May 1991).

Provence, Randy. "Where He Lives and What He Lives For." *Kinesis* 2 (1991).

Schwager, Jeff. "The Voice of Truth: Rick Bass Finds Himself, and His Muse, in Montana." *Village View* (May 31–June 6, 1991).

Slovic, Scott. "A Paint Brush in One Hand and a Bucket of Water in the Other: Nature Writing and the Politics of Wilderness: An Interview with Rick Bass." *Weber Studies* 11 (Fall 1994).

Stobb, Bill. "The Wild into the Word: An Interview with Rick Bass." *ISLE* 5, no. 2 (Summer 1998).

BIOGRAPHICAL/CRITICAL STUDIES AND REVIEWS

Anderson, Roger K. "Viper in the Room: From Rick Bass, Tall Tales Streaked with Rage." Review of *The Watch*. *Houston Chronicle* (April 23, 1989).

Begley, Adam. Review of *Where the Sea Used to Be*. *People Weekly* (July 13, 1998).

Bernstein, Richard. Review of *Where the Sea Used to Be*. *New York Times* (July 1, 1998).

Branch, Michael P. Review of *The Book of Yaak*. *ISLE* 5, no. 2 (August 1998).

Breazeale, Wes. Review of *Where the Sea Used to Be*. *BookPage* (June 1998).

Buffington, Robert. "Tolerating the Short Story." Review of *Platte River*. *Sewanee Review* 102 (Fall 1994).

"Calling in the Troops: An Interview with Former Congressman Pat Williams." *Orion Afield* 1, no. 1 (1997).

Crow, Dallas. Review of *The Ninemile Wolves*. *Audubon* (September/October 1992).

Dixon, Terrell F. "Rick Bass." In *American Nature Writers,* edited by John Elder. New York: Scribner, 1996.

———. Review of *In the Loyal Mountains. Western American Literature* 30 (Spring 1995).

Duffy, Martha. Review of *Oil Notes. Time* (July 17, 1989).

Eckhoff, Sally. Review of *Fiber. New York Times Book Review* (November 1, 1998).

Glasser, Perry. Review of *The Watch. North American Review* (September 1989).

Glover, Charlotte L. Review of *The Sky, the Stars, the Wilderness. Library Journal* (October 1, 1997).

Gorra, Michael. Review of *The Sky, the Stars, the Wilderness. New York Times Book Review* (December 14, 1997).

Grinnell, Jennifer. Review of *The Ninemile Wolves. Bloomsbury Review* (July/August 1992).

Harshaw, Tobin. Review of *In the Loyal Mountains. New York Times Book Review* (July 15, 1995).

Hearon, Shelby. "Caught between Oil's Spell and Nature's Marvels, Geologist Taps into Human Spirit." Review of *Where the Sea Used to Be. Dallas Morning News* (June 7, 1998).

Hedstrom, Elizabeth. Review of *The Ninemile Wolves. National Parks* (November/December 1993).

Hegi, Ursula. "Splendid Isolation." Review of *Winter. New York Times Book Review* (February 10, 1991).

Herndon, John. "Texas Authors Broaden Horizons: Writers Restore Art of Engaging Humans with Natural Landscapes." Review of *The Ninemile Wolves. Austin American-Statesman* (July 5, 1992).

Hershey, Jay. Review of *Where the Sea Used to Be. Wall Street Journal* (June 12, 1998).

Kamie, Mark. Review of *The Watch*. *New Leader* (February 6, 1989).

Koenig, Rhoda. "The Long and Winding Road." Review of *Oil Notes*. *New York Times Book Review* (July 17, 1989).

Lemon, Lee. Review of *The Watch*. *Prairie Schooner* (Summer 1990).

LeMonds, James. Review of *Platte River*. *English Journal* (November 1994).

Leschak, Peter M. Review of *The Book of Yaak*. *New York Times Book Review* (December 1, 1996).

Little, Charles E. Review of *The Lost Grizzlies*. *Wilderness* (Fall 1995).

———. Review of *The Ninemile Wolves*. *Wilderness* (Fall 1992).

———. Review of *The Watch*. *Wilderness* (Summer 1989).

———. Review of *Wild to the Heart*. *Wilderness* (Summer 1988).

———. Review of *Winter*. *Wilderness* (Summer 1991).

Long, David. "Rick Bass: Lessons from the Wilderness." *Publishers Weekly* (June 26, 1995).

Lowell, Susan. "Country Love and Naked Laundresses." Review of *The Watch*. *New York Times Book Review* (March 5, 1989).

Lyon, Thomas J. Review of *Winter*. *Sierra* (September/October 1991).

Mardon, Mark. Review of *The Lost Grizzlies*. *Sierra* (January/February 1996).

Markus, Tim. Review of *The Book of Yaak*. *Library Journal* (January 1997).

———. Review of *The Ninemile Wolves*. *Library Journal* (May 15, 1992).

McCombie, Brian. Review of *The Lost Grizzlies.*
Booklist (November 1, 1995).

McManus, James. "Geology Is Destiny." Review of
*Where the Sea Used to Be. New York Times Book
Review* (August 2, 1998).

McNamee, Thomas. Review of *The Lost Grizzlies. New
York Times Book Review* (November 26, 1995).

Merrill, Christopher. Review of *The Watch. New
England Review and Bread Loaf Quarterly* (Winter
1989).

Miles, John C. Review of *The Ninemile Wolves.
Amicus Journal* (Winter 1993).

Miller, David. "Slices of Wildlife." *Sewanee Review*
(Spring 1991).

Murray, John. Review of *The Book of Yaak.
Bloomsbury Review* (May/June 1997).

Neville, Bruce. Review of *The Lost Grizzlies. Library
Journal* (November 1, 1995).

Nichols, Bruce. "Tapping a Personal Reservoir:
Geologist's Stories Now Writer's Books." *Dallas
Morning News* (July 4, 1990).

Nicholson, David. "Small People Against a Big Sky."
Review of *Where the Sea Used to Be. Washington
Post* (July 7, 1998).

Pavey, Ruth. Review of *The Watch. New Statesman
and Society* (December 1, 1989).

Perney, Linda. Review of *The Lost Grizzlies. Audubon*
(January/February 1996).

Peterson, V. R. Review of *Oil Notes. People Weekly*
(September 11, 1989).

Prescott, Peter S. Review of *The Watch. Newsweek*
(January 9, 1989).

Ratner, Rochelle. Review of *Wild to the Heart. Library
Journal* (August 1991).

Ray, Janisse. "Up Against Openings." *Missoula Independent* (August 28, 1997).

Review of *The Book of Yaak*. *Appalachia* (June 15, 1998).

Review of *In the Loyal Mountains*. *Publishers Weekly* (May 1, 1995).

Review of *The Lost Grizzlies*. *Publishers Weekly* (October 2, 1995).

Review of *The Ninemile Wolves*. *Economist* (June 20, 1992).

Review of *The Ninemile Wolves*. *Publishers Weekly* (May 4, 1992).

Review of *Oil Notes*. *Earth Science* (Summer 1990).

Review of *Oil Notes*. *Publishers Weekly* (October 5, 1990).

Review of *Platte River*. *Kirkus Reviews* (December 15, 1993).

Review of *Platte River*. *Publishers Weekly* (January 3, 1994).

Review of *The Sky, the Stars, the Wilderness*. *Publishers Weekly* (September 15, 1997).

Review of *The Watch*. *Time* (February 20, 1989).

Review of *The Watch*. *Virginia Quarterly Review* (Autumn 1989).

Review of *Where the Sea Used to Be*. *Kirkus Reviews* (April 15, 1998).

Review of *Where the Sea Used to Be*. *Library Journal* (March 15, 1998).

Review of *Where the Sea Used to Be*. *Mother Jones* (July/August 1998).

Review of *Where the Sea Used to Be*. *Publishers Weekly* (March 30, 1998).

Robertson, Ray. Review of *Platte River*. *Southwestern American Literature* (Fall 1994).

Rueckert, William H. Review of *The Ninemile Wolves. Georgia Review* (Spring 1993).

Ruiter, David. "Life on the Frontier: Frederick Jackson Turner and Rick Bass." *Journal of the American Studies Association of Texas* 26 (October 1995).

Rungren, Lawrence. Review of *In the Loyal Mountains. Library Journal* (May 15, 1995).

———. Review of *Winter. Library Journal* (February 15, 1991).

Saari, Jon. Review of *The Watch. Antioch Review* (Fall 1989).

Schubnell, Matthias. "Bass's *Stories* Show Humor, Suspense, and a Unique Voice." Review of *The Watch. Texas Books in Review* (Fall 1989).

Scialabba, George. "Geology and Transcendence in Montana." Review of *Where the Sea Used to Be. Boston Sunday Globe* (June 28, 1998).

Seaman, Donna. Review of *In the Loyal Mountains. Booklist* (June 1, 1995).

———. Review of *The Lost Grizzlies. Booklist* (December 1, 1996).

Sherwood, Steve. "The Watch—Rick Bass." *Composition Studies/Freshman English News* 23, no. 1 (Spring 1995).

Skow, John. Review of *Where the Sea Used to Be. Time* (June 29, 1998).

———. "The Wilderness Within: Novellas in Which Nature Is More Than Scenery." *Time* (December 8, 1997).

Smith, Starr E. Review of *Platte River. Library Journal* (January 1994).

Solomon, Chris. "The Writer, the Fighter." *Seattle Times* (December 21, 1997).

Steinberg, Sybil. Review of *The Watch. Publishers Weekly* (November 18, 1988).

Stuttaford, Genevieve. Review of *Oil Notes. Publishers Weekly* (May 26, 1989).

———. Review of *Winter. Publishers Weekly* (January 4, 1991).

Sullivan, Matt. Review of *In the Loyal Mountains.* (March/April 1996).

Tilghman, Christopher. *"Platte River Stories May Be Author's Best." Eugene Register-Guard* (April 3, 1994).

Unger, Amanda. Review of *The Lost Grizzlies. Journal of the West* (April 1998).

Wanner, Irene. Review of *The Lost Grizzlies. Seattle Times* (January 7, 1996).

Weltzien, Alan O. *Rick Bass.* Western Writers Series no. 134. Boise, Idaho: Boise State University, 1998.

Wright, Ronald. Review of *Oil Notes. Times Literary Supplement* (November 24, 1989).

Appendix

HOW TO HELP THE YAAK'S LAST ROADLESS AREAS

by Rick Bass

I've said a lot in this book about my own letter writing. If you are inclined to help out with this effort, you'll find that a fine place to begin lobbying for the Yaak's unprotected wilderness, and for other wilderness areas, is with your own senators and representatives; look up the names and then send your letters either to U.S. Senate, Washington, DC 20510 or to U.S. House of Representatives, Washington, DC 20515. To get the specific names, addresses, phone numbers, and E-mail addresses for your representatives in both the Senate and the House, call (202) 224-3121.

Other key officials determining the fate of the Yaak include the chief of the Forest Service (P.O. Box 96090, Washington, DC 20090), the secretary of agriculture (14th St. and Independence Ave., Washington, DC 20250), the regional forester (P.O. Box 7669, Missoula, MT 59807), the Kootenai National Forest supervisor

(506 Highway 2 West, Libby, MT 59923), and the governor of Montana (State Capitol, Helena, MT 59620). Of course, the president (The White House, 1600 Pennsylvania Ave., Washington, DC 20500) and the vice president (Old Executive Office Building, Washington, DC 20501) would also enjoy hearing from you.

ACKNOWLEDGMENTS FOR "BROWN DOG OF THE YAAK"

by Rick Bass

I'm very grateful to the publisher of this series, Emilie Buchwald, production editor, Laurie Buss, managing editor, Beth Olson, the copy editor, and the staff of Milkweed, and to the series editor, Scott Slovic. I'm grateful to Tom and Nancy Oar—Colter's parents—and to Tim Linehan and Maddie, his hunting partners. I'm grateful to Colter's friends, Jarrett Thompson and Doug Griffiths.

I'm grateful also for passages from the following writers, referred to in this book: Thomas Merton, Osborne Russell *(Journal of a Trapper)*, Henry David Thoreau, Annie Dillard *(The Writing Life)*, Ernest Hemingway, Jim Harrison *(Just Before Dark)*, and Tom Davis.

Portions of this book appeared in slightly different form in *Sports Afield*. Gratitude goes also to my family, friends, and neighbors; to the Yaak Valley Forest Council, the Montana Wilderness Association, the Cabinet Resources Group, Round River

165

Conservation Studies, and the many other organizations and individuals who have helped provide support for the idea of protecting the last wild roadless cores in the Yaak while continuing to nurture a sustainable local economy that is based upon natural resources—one of which is wilderness, a most immeasurable and irreplaceable value. Thank you for any help you can give, as a reader and an activist.

WORKS CITED

p. 58 Thomas Merton, *Conjectures of a Guilty Bystander* (Garden City, N.Y.: Doubleday, 1966), 73.

p. 61 Ruth Stone, "Laguna Beach," in *Second-Hand Coat: Poems New and Selected* (Cambridge: Yellow Moon Press, 1991), 81.

pp. 61–62 Osborne Russell, *Osborne Russell's Journal of a Trapper,* ed. Aubrey L. Haines (Portland: Oregon Historical Society, 1955), 74–75.

p. 65 James Dickey, *Poems 1957–1967* (Middletown, Conn.: Wesleyan University Press, 1967), 278.

p. 67 Henry David Thoreau, *The Journal of Henry David Thoreau,* vol. 8, ed. Bradford Torrey and Francis H. Allen (Boston: Houghton Mifflin, 1906), 221.

p. 68 Henry David Thoreau, *Walden* (1854), ed.
 J. Lyndon Shanley (Princeton: Princeton
 University Press, 1971), 17.

pp. 74–77 Osborne Russell, *Osborne Russell's Journal
 of a Trapper,* ed. Aubrey L. Haines
 (Portland: Oregon Historical Society,
 1955), 128.

p. 96 Annie Dillard, *The Writing Life* (New
 York: Harper and Row, 1989), 78–79.

p. 96 Franz Kafka, *Letters to Friends, Family,
 and Editors,* trans. Richard Winston and
 Clara Winston (New York: Schocken
 Books, 1977), 16.

p. 97 George Plimpton, "An Interview with
 Ernest Hemingway," *Paris Review,* no. 18
 (Spring 1958).

p. 97 Ernest Hemingway, *Ernest Hemingway on
 Writing,* ed. Larry W. Phillips (New York:
 Scribner's, 1984), 41–42.

p. 99 Jim Harrison, *Just Before Dark*
 (Livingston, Mont.: Clark City Press,
 1991), 318.

p. 107 Wallace Stevens, quoted in Jim Harrison,
 Just Before Dark, vii.

p. 107 Jim Harrison, *Just Before Dark,* xi–xii.

p. 108 Jim Harrison, *Just Before Dark,* 295.

pp. 110–11 Tom Davis, "Sweetheart of the Pines,"
 Pointing Dog Journal (January/February
 1997).

p. 113 Goethe, quoted in Jim Harrison, *Just
 Before Dark,* 193.

p. 126 Annie Dillard, "Living Like Weasels," in
 Teaching a Stone to Talk (New York:
 Harper and Row, 1982), 11.

p. 126 Rick Bass, "On Willow Creek," in *Heart of
 the Land: Essays on Last Great Places,* ed.
 Joseph Barbato and Lisa Weinerman
 (New York: Pantheon, 1994), 7.

p. 127 Rick Bass, "On Willow Creek," 12.

p. 129 Rick Bass, "River People," in *Wild to the
 Heart* (New York: Norton, 1987), 158.

p. 130 Scott Slovic, "A Paint Brush in One Hand
 and a Bucket of Water in the Other:
 Nature Writing and the Politics of
 Wilderness: An Interview with Rick
 Bass," in *Weber Studies* (Fall 1994): 26.

p. 131 Rick Bass, "Choteau," in *The Watch* (New
 York: Norton, 1987), 46–47.

p. 132 Rick Bass, *The Ninemile Wolves*
 (Livingston, Mont.: Clark City Press,
 1992), 3.

pp. 132–33 Rick Bass, "Wise Blood," in *The Ninemile
 Wolves,* 139–40.

p. 133 Edward Abbey, *Desert Solitaire* (New York: Ballantine, 1971), 148–49.

p. 135 Rick Bass, *The Book of Yaak* (Boston: Houghton Mifflin, 1996), xiii.

p. 135 Terry Tempest Williams, *Refuge* (New York: Vintage, 1992), 290.

p. 136 Rick Bass, *The Book of Yaak,* 90.

SCOTT SLOVIC, founding president of the Association for the Study of Literature and Environment (ASLE), currently serves as editor of the journal *ISLE: Interdisciplinary Studies in Literature and Environment.* He is the author of *Seeking Awareness in American Nature Writing: Henry Thoreau, Annie Dillard, Edward Abbey, Wendell Berry, Barry Lopez* (University of Utah Press, 1992); his coedited books include *Being in the World: An Environmental Reader for Writers* (Macmillan, 1993), *Reading the Earth: New Directions in the Study of Literature and the Environment* (University of Idaho Press, 1998), and *Literature and the Environment: A Reader on Nature and Culture* (Addison Wesley Longman, 1999). Currently he is an associate professor of English and the director of the Center for Environmental Arts and Humanities at the University of Nevada, Reno.

More Books on The World As Home from Milkweed Editions

To order books or for more information, contact Milkweed at (800) 520-6455 or visit our website (www.milkweed.org).

Boundary Waters:
The Grace of the Wild
Paul Gruchow

Grass Roots:
The Universe of Home
Paul Gruchow

The Necessity of Empty Places
Paul Gruchow

The Dream of the Marsh Wren:
Writing As Reciprocal Creation
Pattiann Rogers

The Book of the Tongass
Edited by Carolyn Servid and Donald Snow

Homestead
Annick Smith

Testimony:
Writers of the West Speak
On Behalf of Utah Wilderness
Compiled by Stephen Trimble
and Terry Tempest Williams

OTHER BOOKS OF INTEREST TO THE WORLD AS HOME READER:

Essays

The Heart Can Be Filled Anywhere on Earth:
Minneota, Minnesota
Bill Holm

Shedding Life:
Disease, Politics, and Other Human Conditions
Miroslav Holub

Children's Novels

No Place
Kay Haugaard

The Monkey Thief
Aileen Kilgore Henderson

Treasure of Panther Peak
Aileen Kilgore Henderson

The Dog with Golden Eyes
Frances Wilbur

Anthologies

Sacred Ground:
Writings about Home
Edited by Barbara Bonner

Verse and Universe:
Poems about Science and Mathematics
Edited by Kurt Brown

Poetry

Boxelder Bug Variations
Bill Holm

Butterfly Effect
Harry Humes

Eating Bread and Honey
Pattiann Rogers

Firekeeper:
New and Selected Poems
Pattiann Rogers

THE WORLD AS HOME, the nonfiction publishing program of Milkweed Editions, is dedicated to exploring our relationship to the natural world. Not espousing any particular environmentalist or political agenda, these books are a forum for distinctive literary writing that not only alerts the reader to vital issues but offers personal testimonies to living harmoniously with other species in urban, rural, and wilderness communities.

MILKWEED EDITIONS publishes with the intention of making a humane impact on society, in the belief that literature is a transformative art uniquely able to convey the essential experiences of the human heart and spirit. To that end, Milkweed publishes distinctive voices of literary merit in handsomely designed, visually dynamic books, exploring the ethical, cultural, and esthetic issues that free societies need continually to address. Milkweed Editions is a not-for-profit press.

Typeset in Stone Serif
by Stanton Publication Services, Inc.

CPSIA information can be obtained
at www.ICGtesting.com
Printed in the USA
JSHW060211300722
28597JS00001B/4